Disney

DREAMS COLLECTION

THOMAS KINKADE
S T U D I O S

COLORING BOOK

Andrews McMeel
PUBLISHING®

Thomas
Kinkade

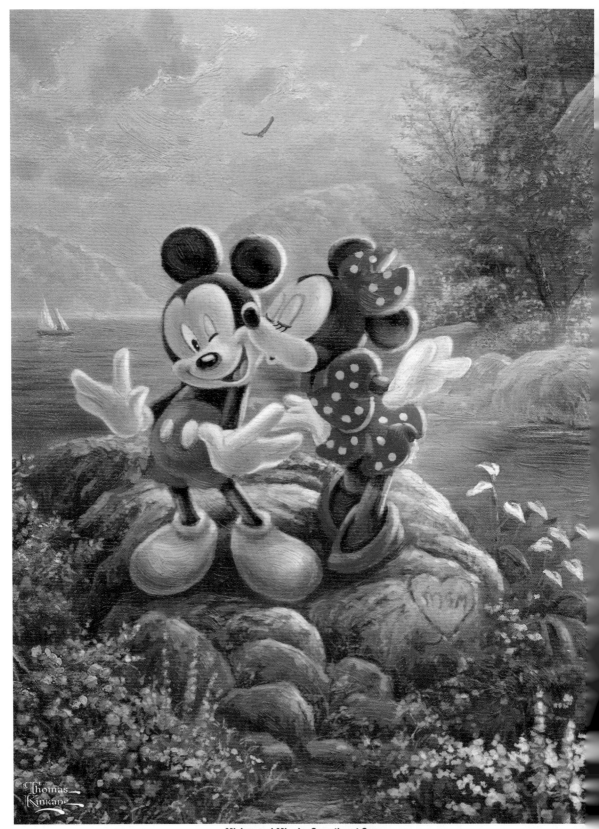

Mickey and Minnie–Sweetheart Cove

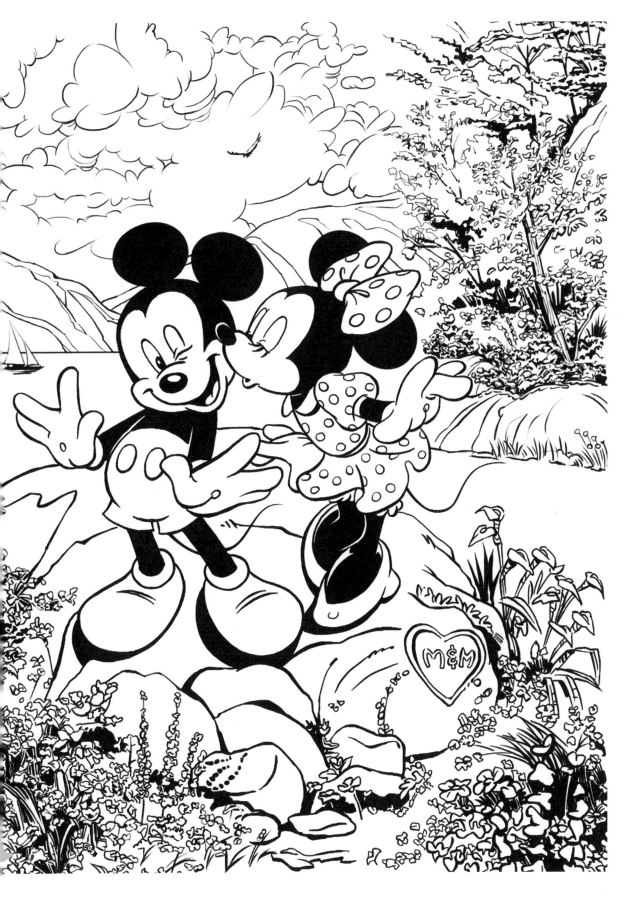

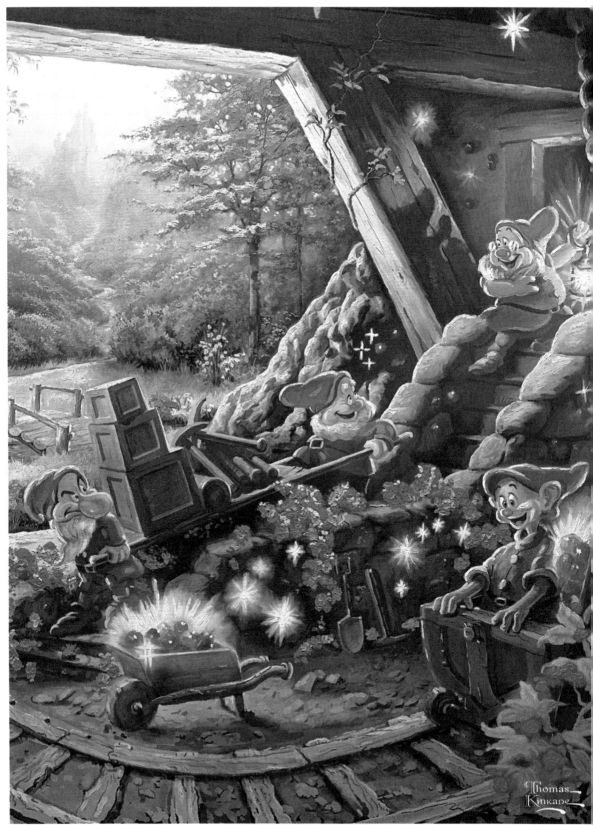

Snow White and the Seven Dwarfs

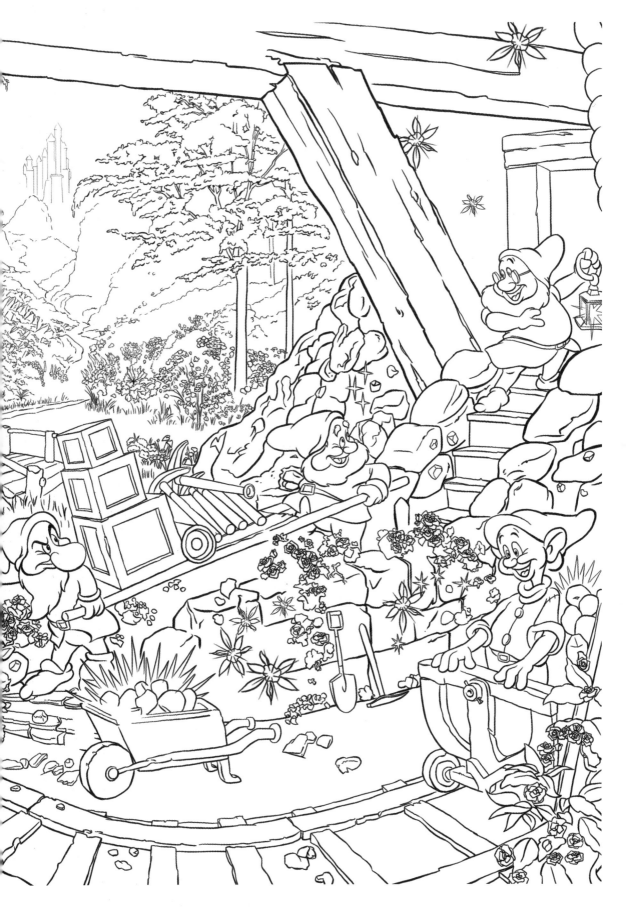

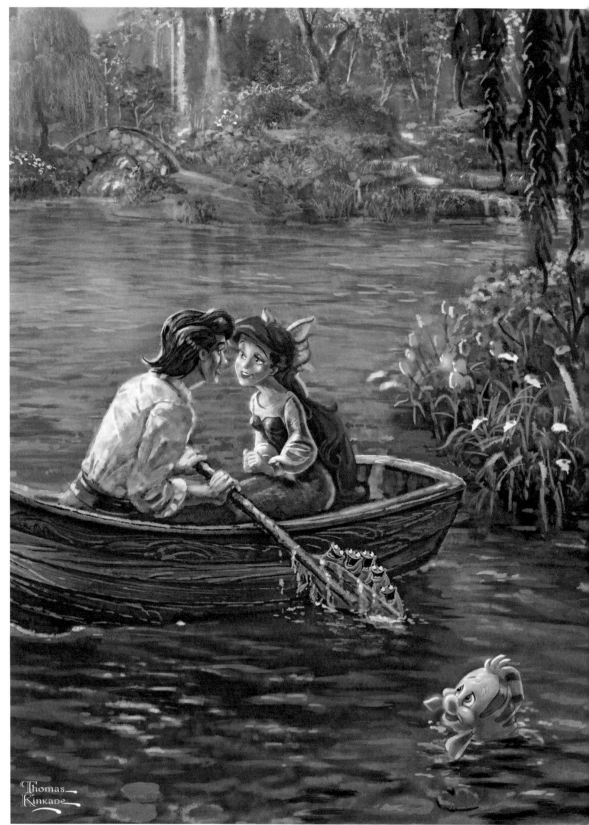

The Little Mermaid II

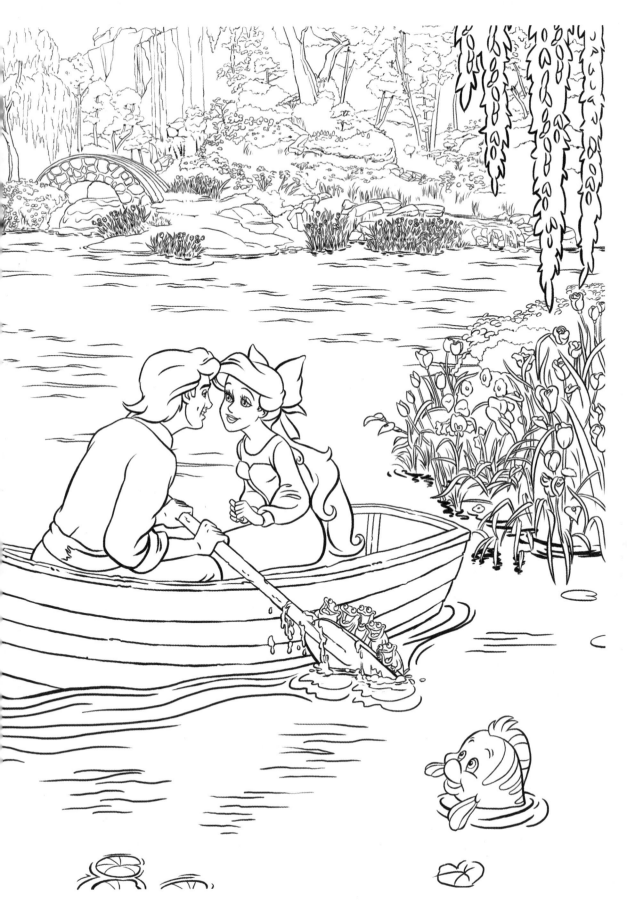

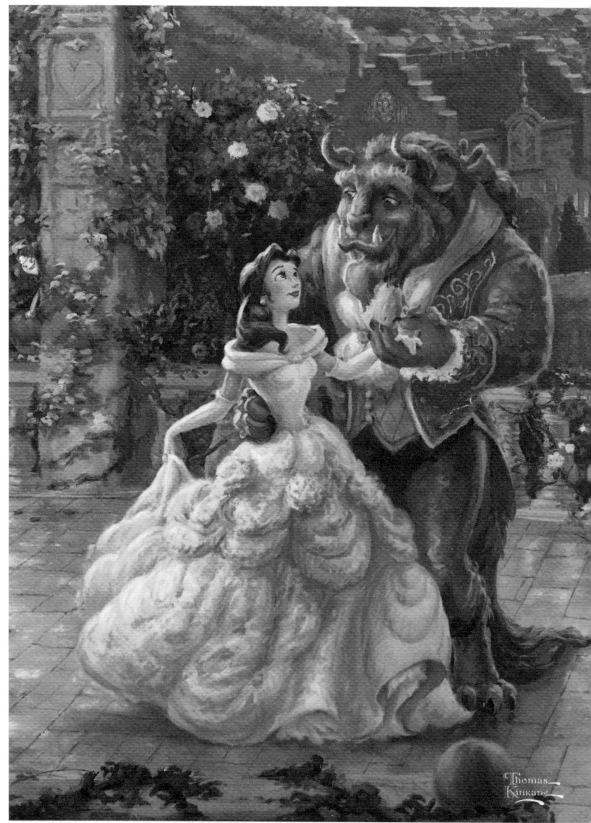

Beauty and the Beast Dancing in the Moonlight

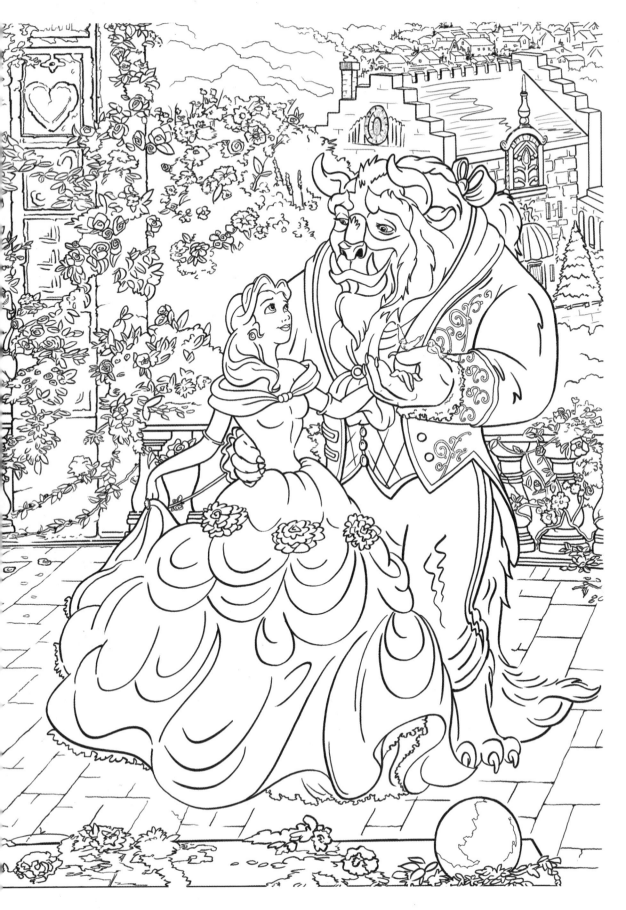

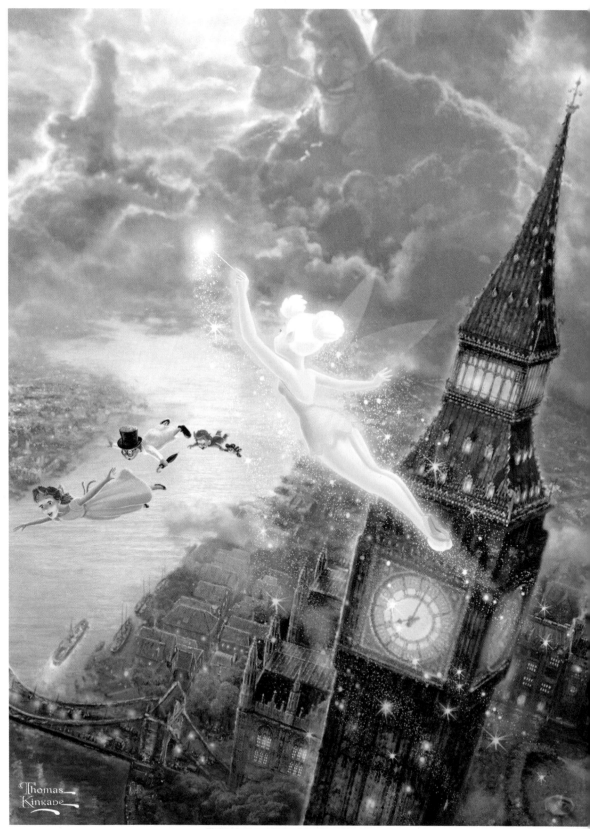

Tinker Bell and Peter Pan Fly to Never Land

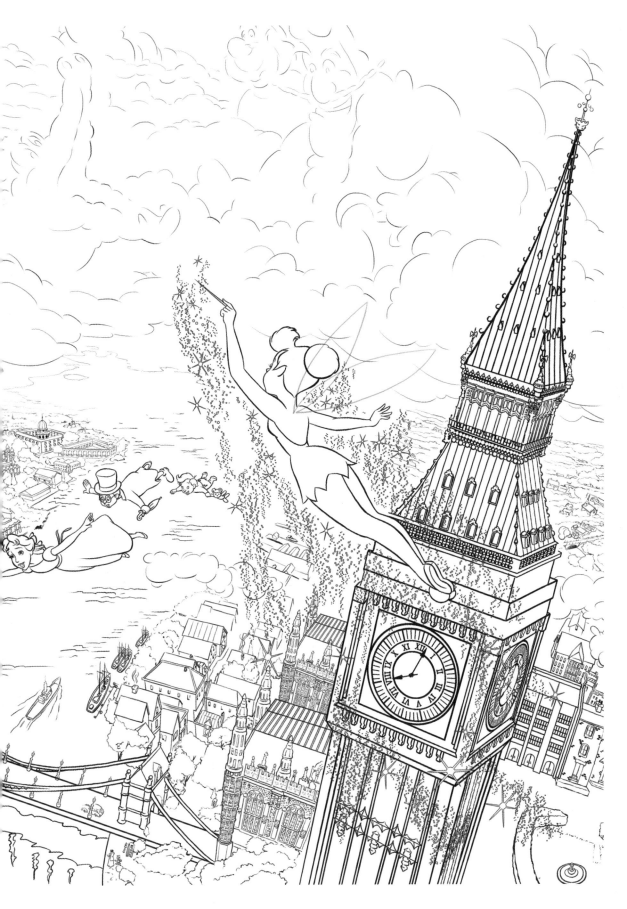

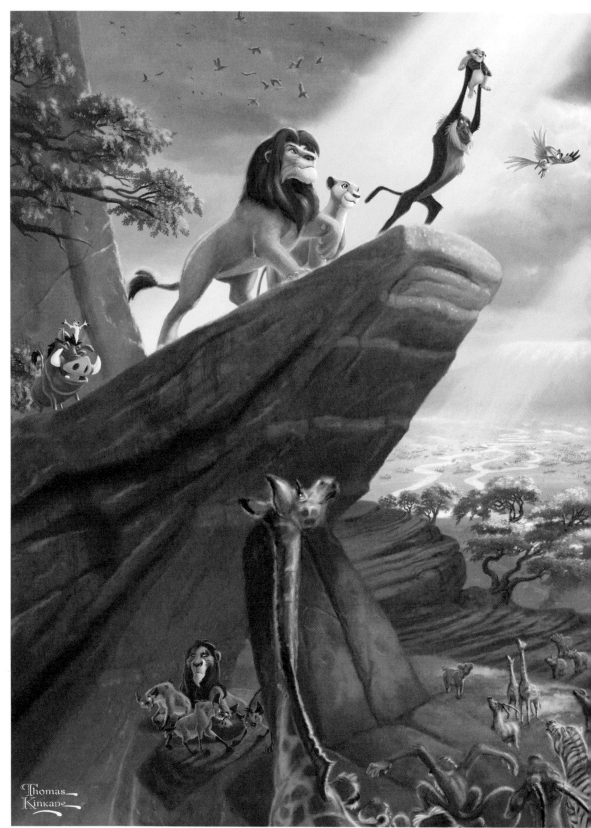

The Lion King

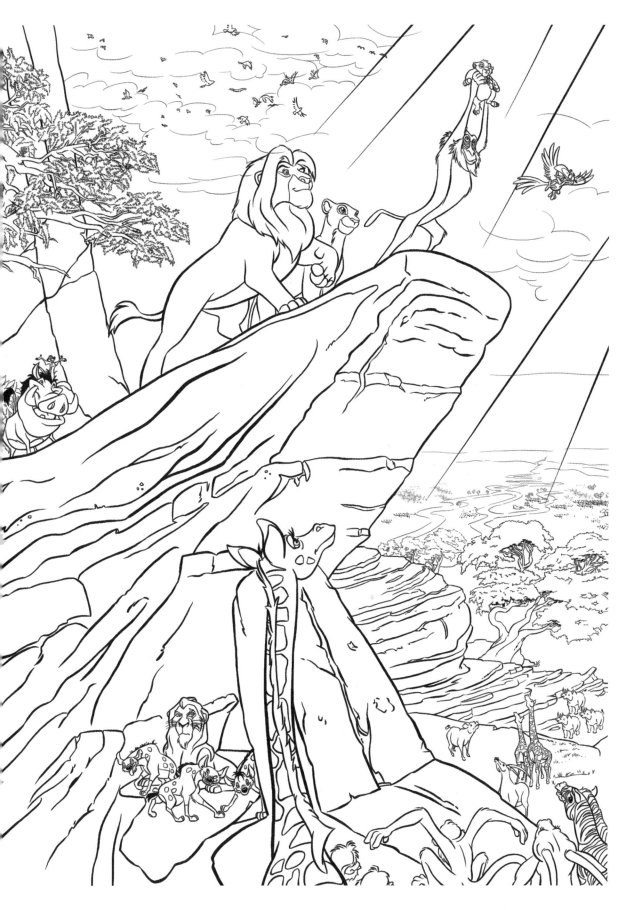

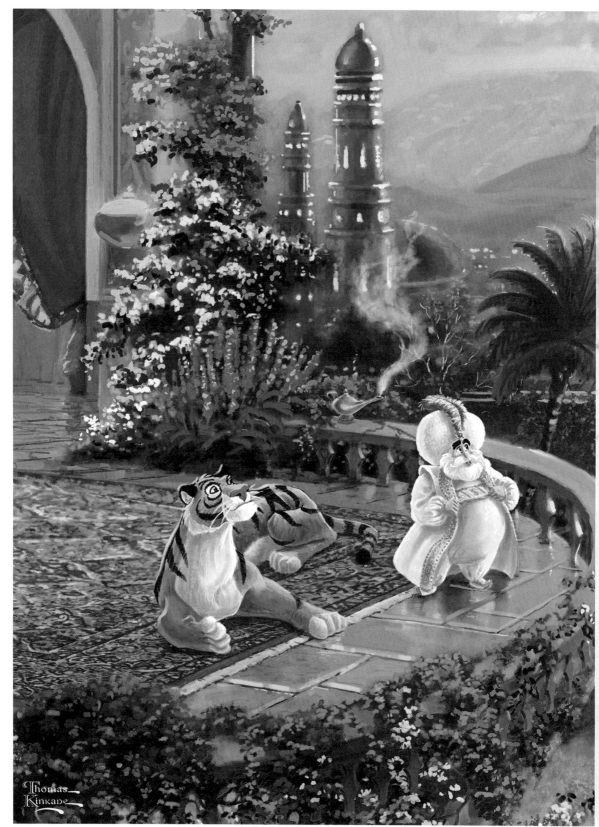

Aladdin

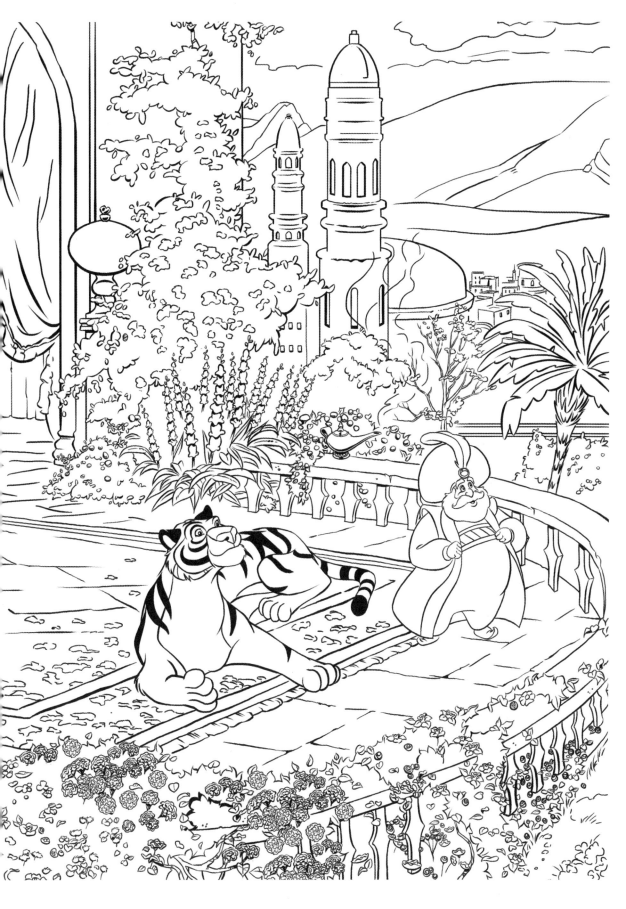

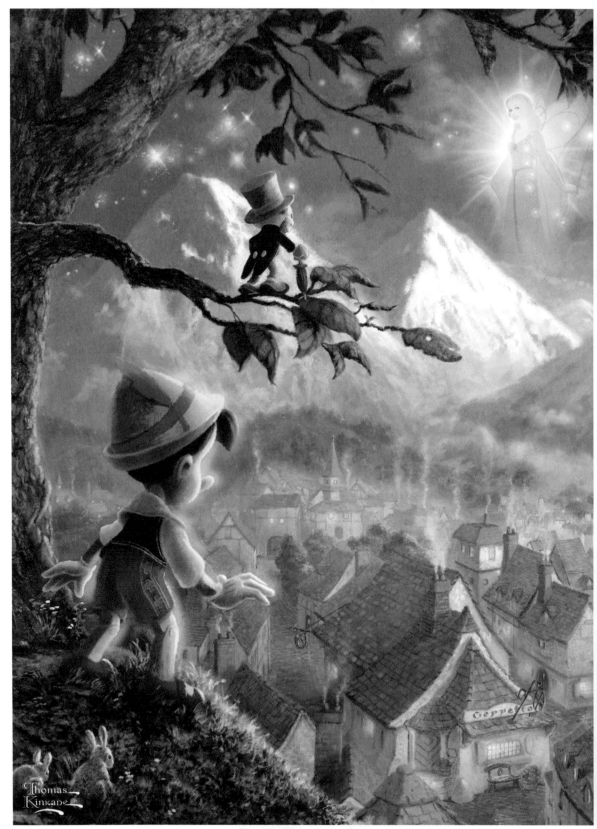

Pinocchio Wishes Upon a Star

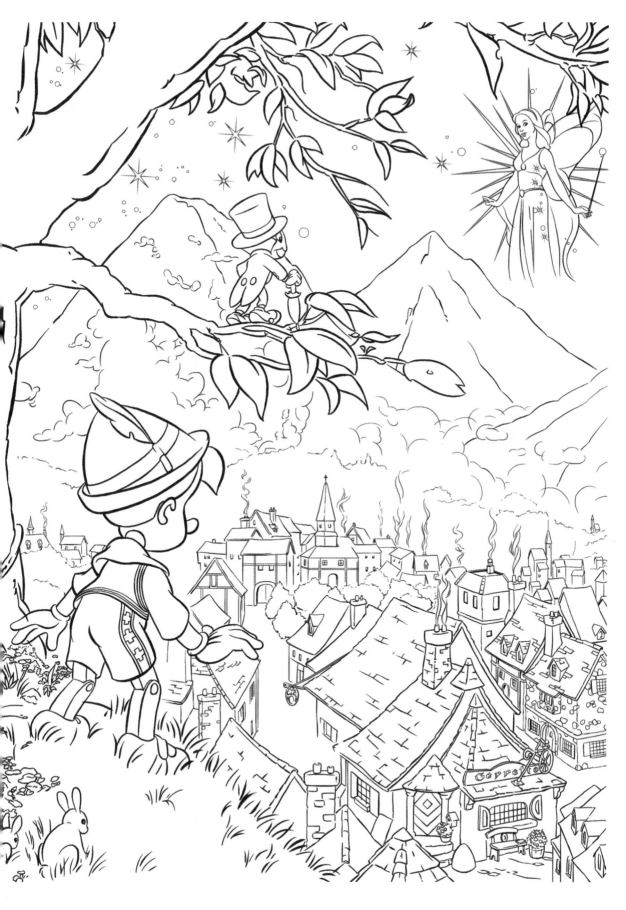

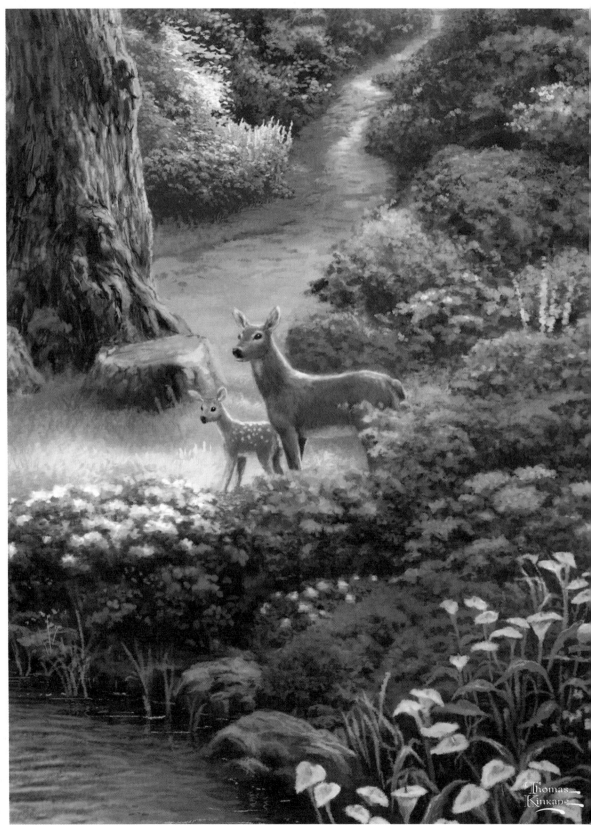

Snow White Discovers the Cottage

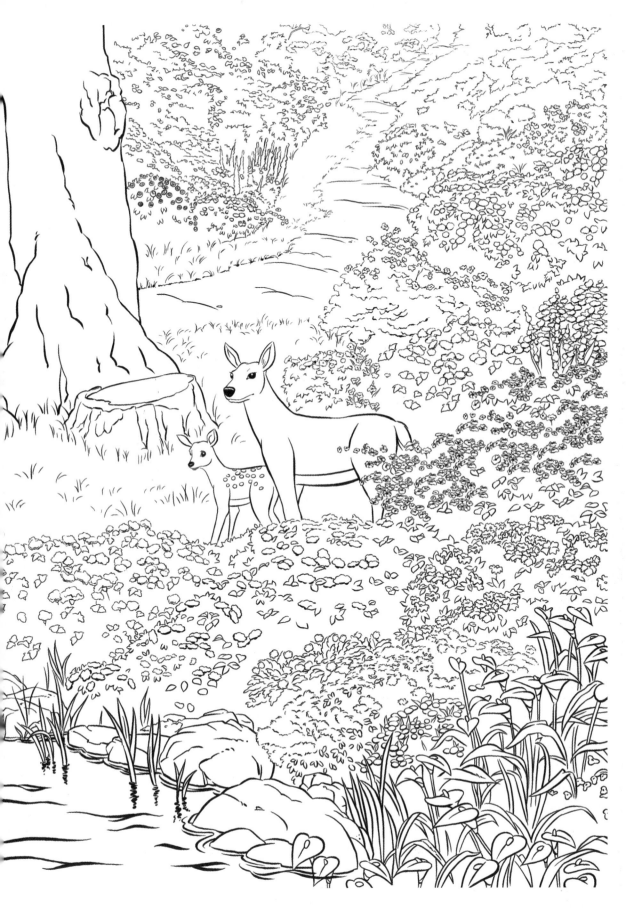

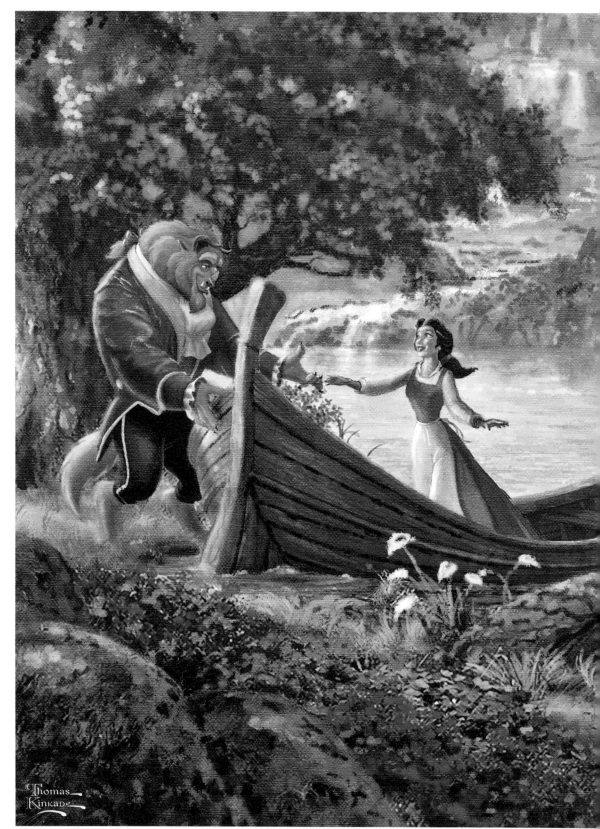

Beauty and the Beast II

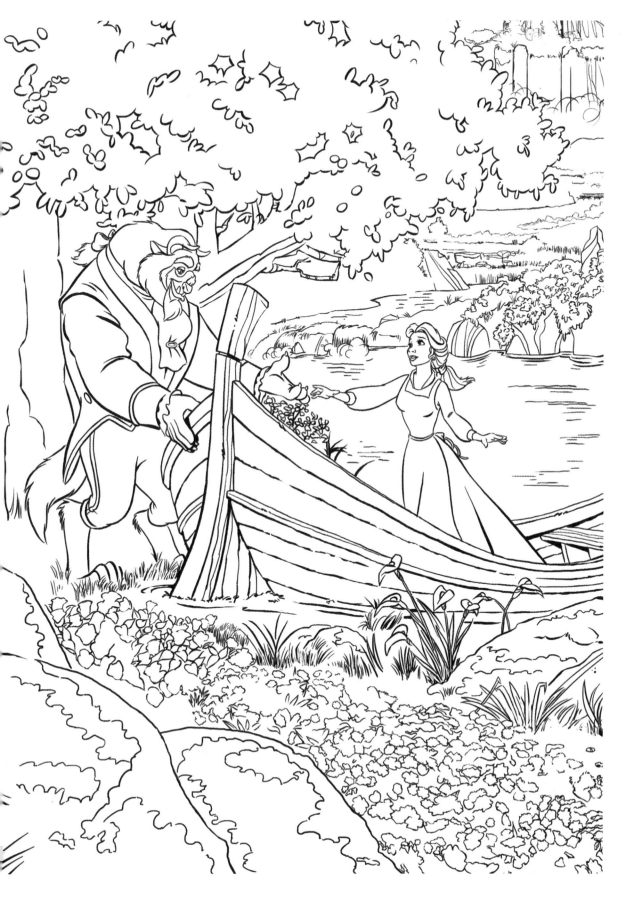

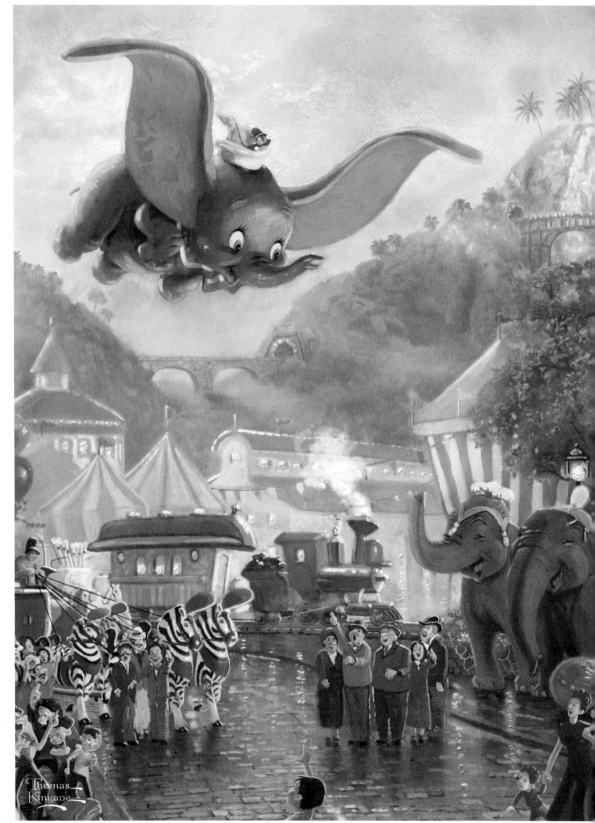

Dumbo

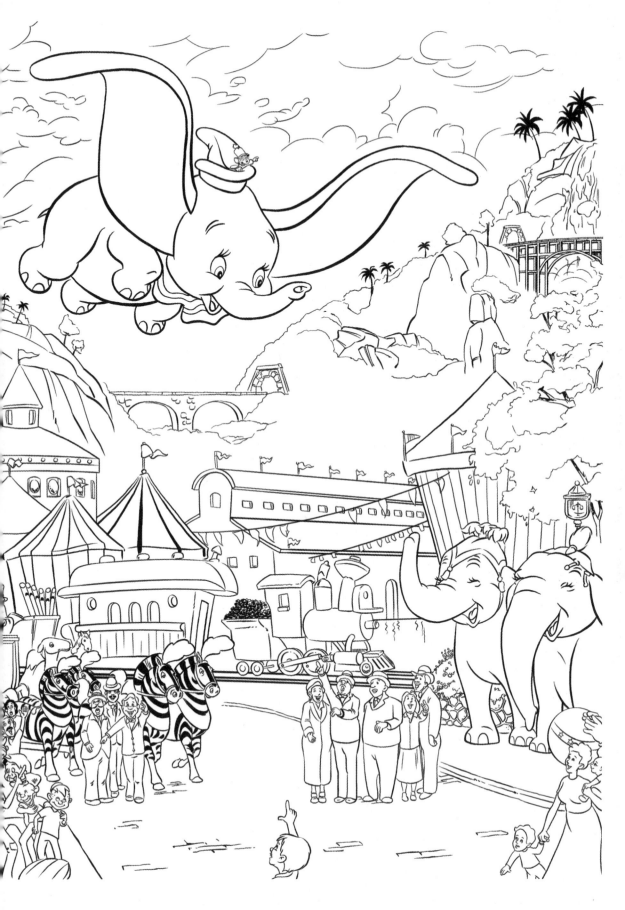

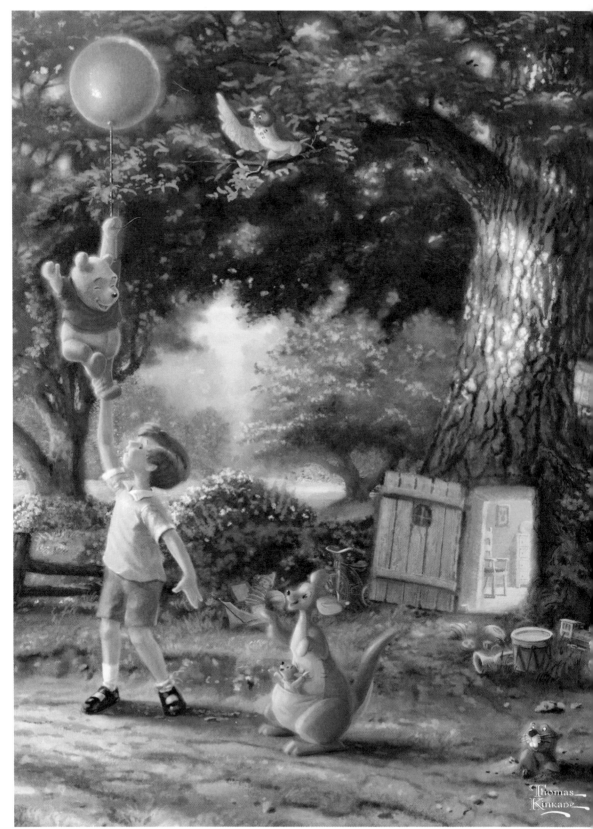

Winnie the Pooh II

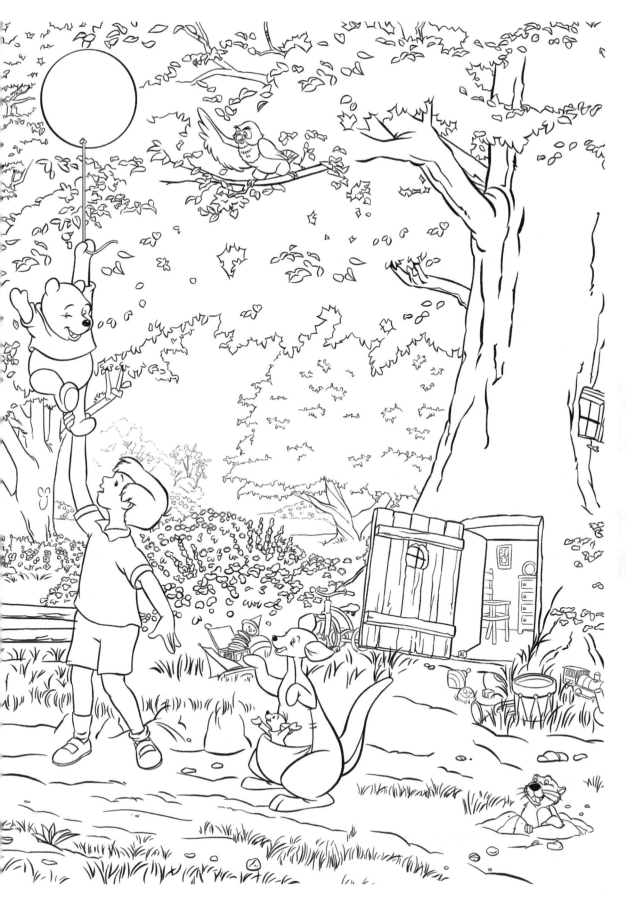

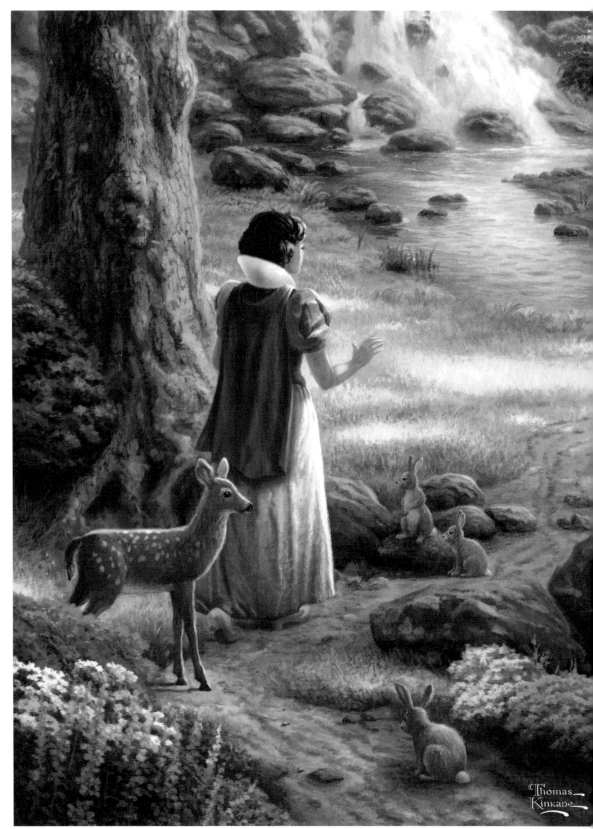

Snow White Discovers the Cottage

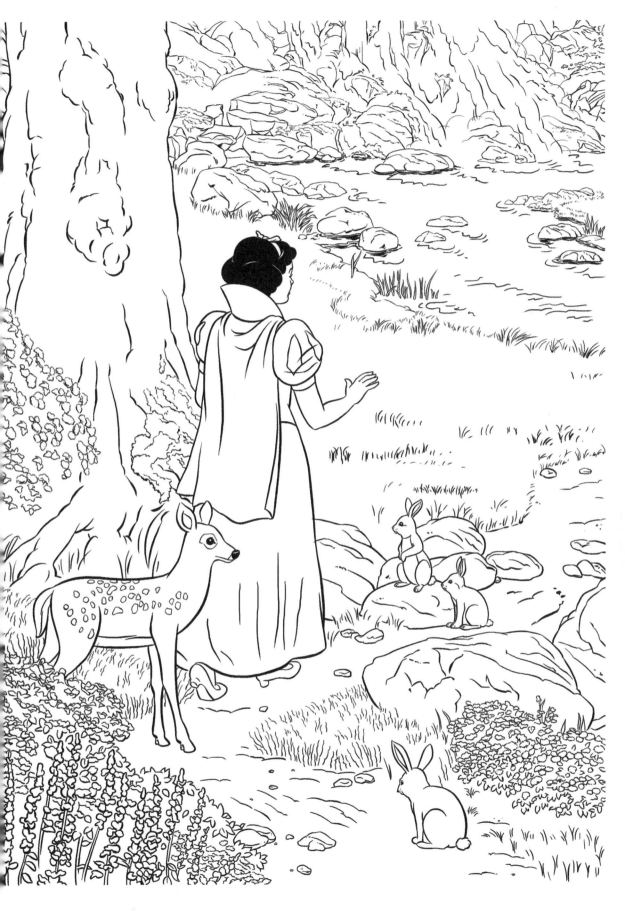

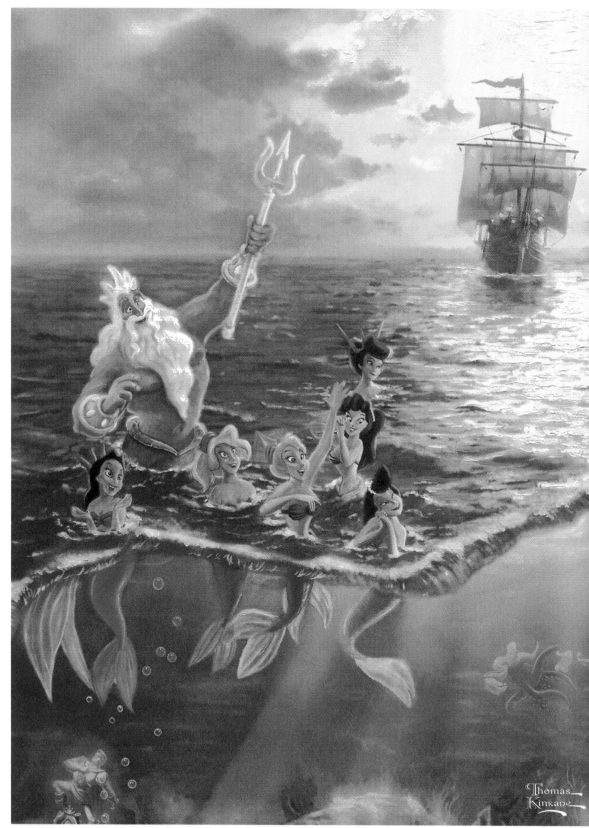

The Little Mermaid

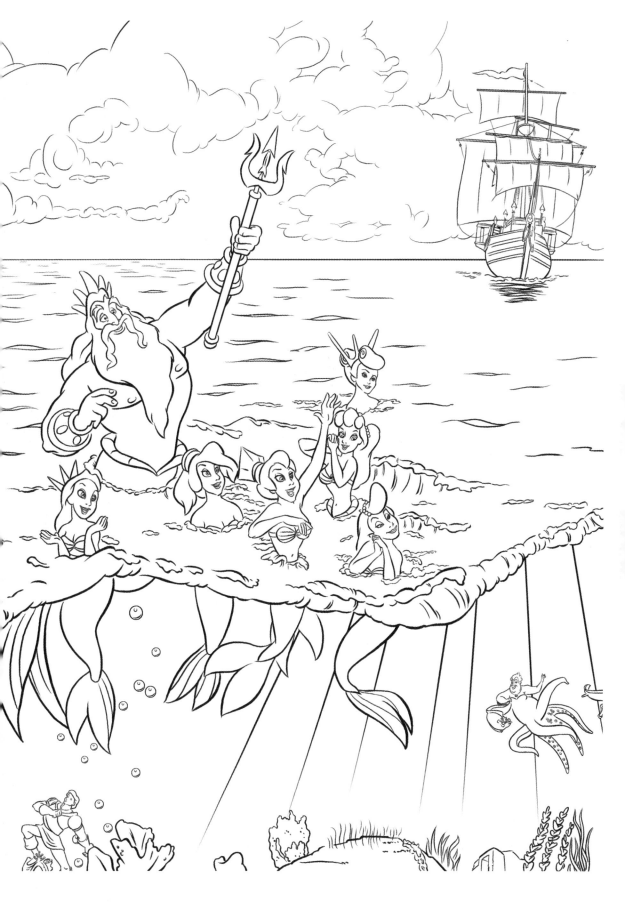

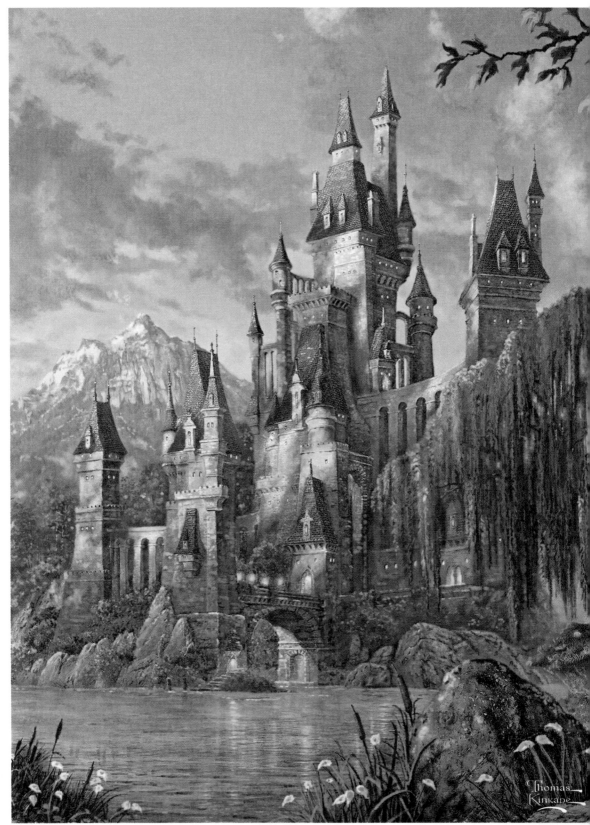

Beauty and the Beast II

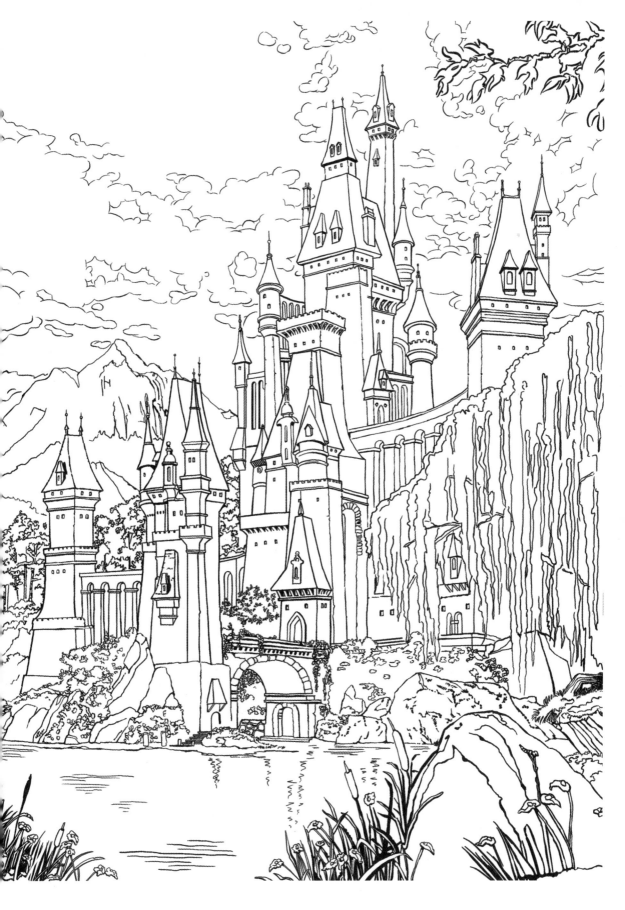

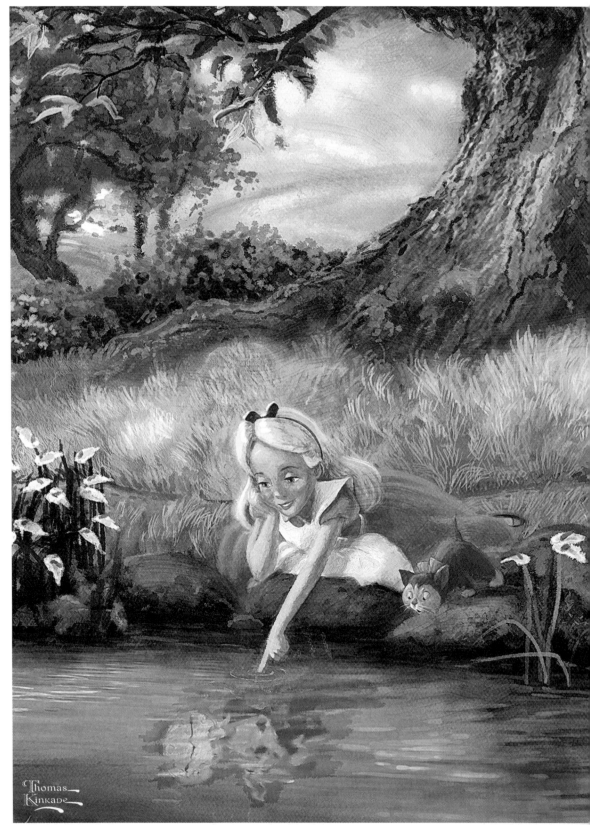

Alice in Wonderland

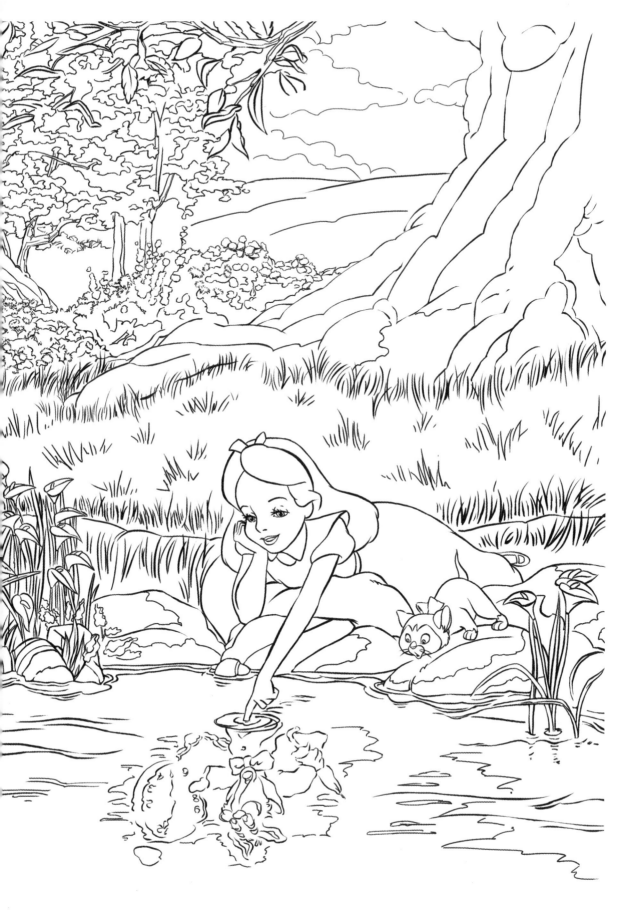

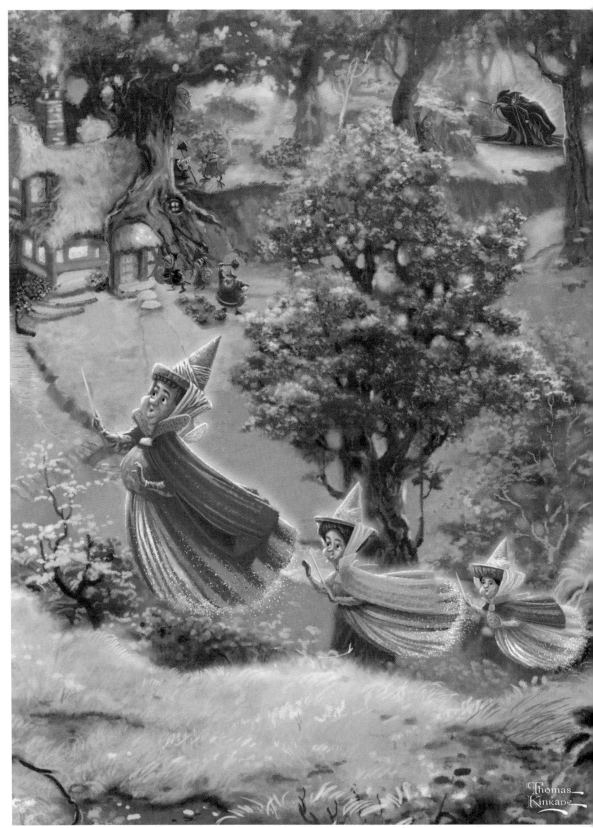

Sleeping Beauty

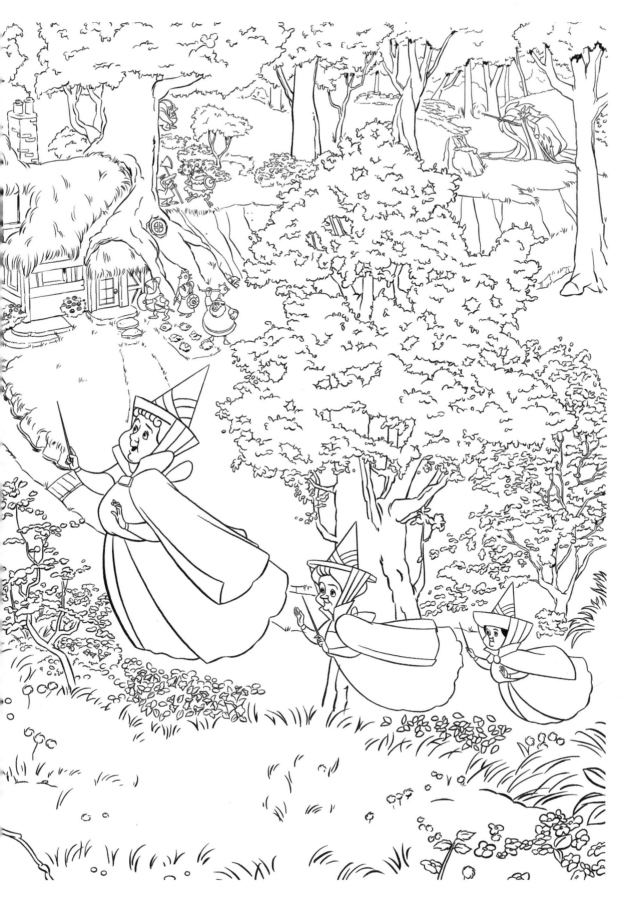

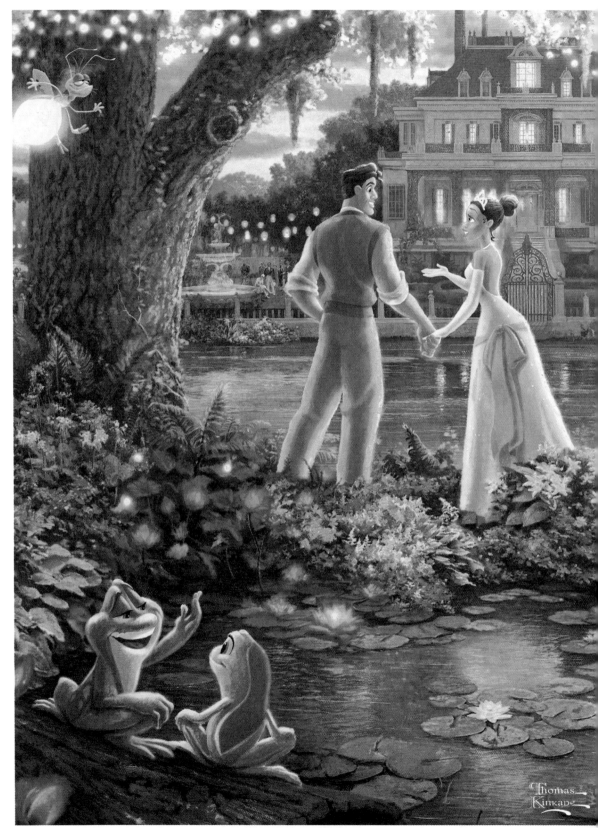

The Princess and the Frog

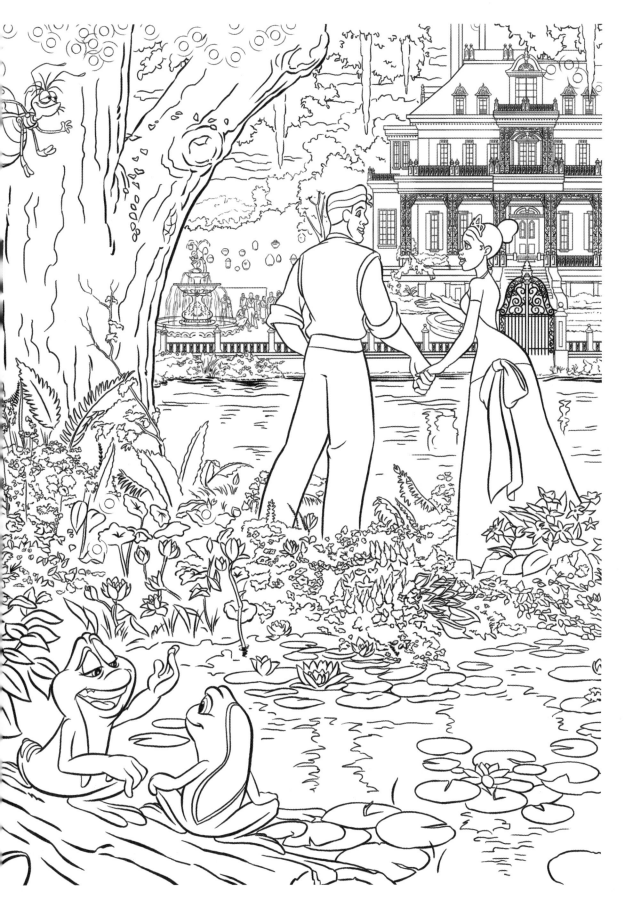

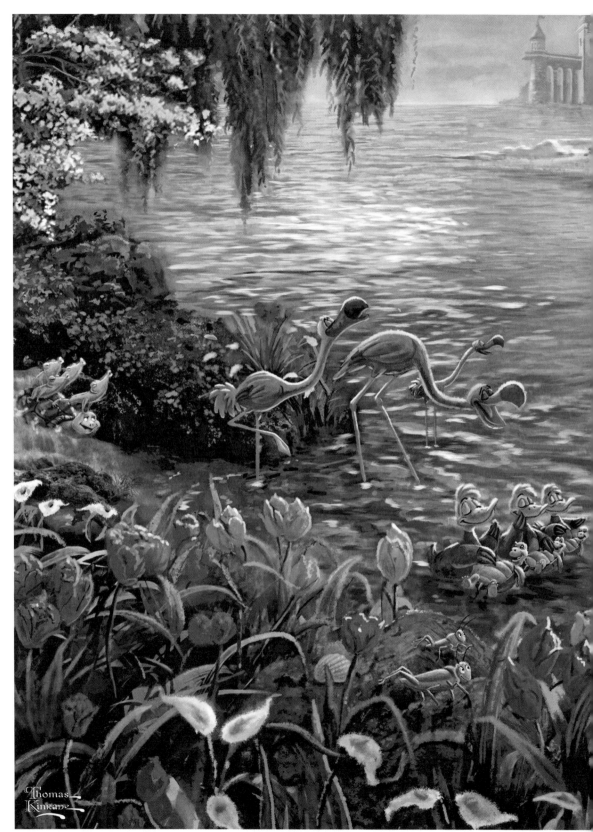

The Little Mermaid II

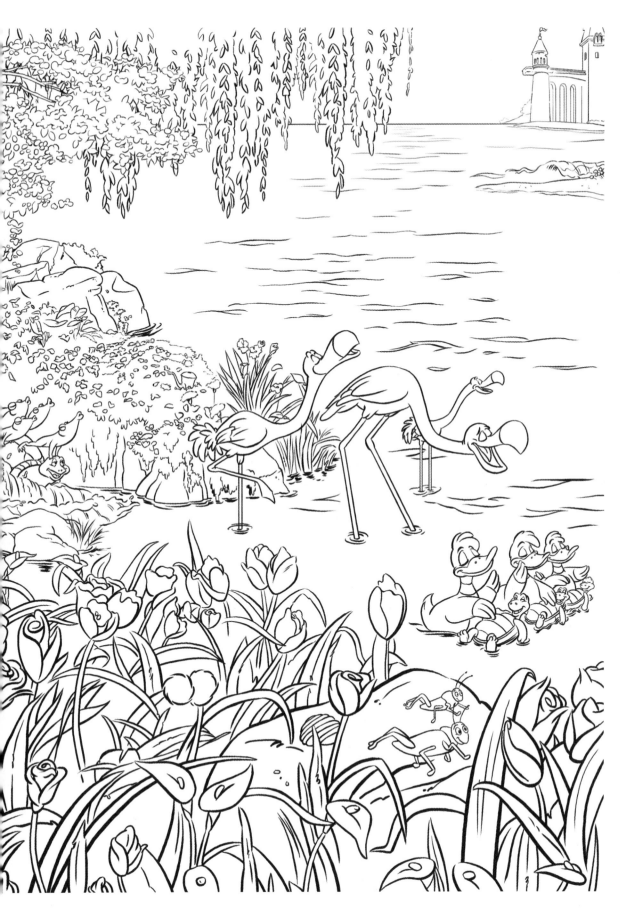

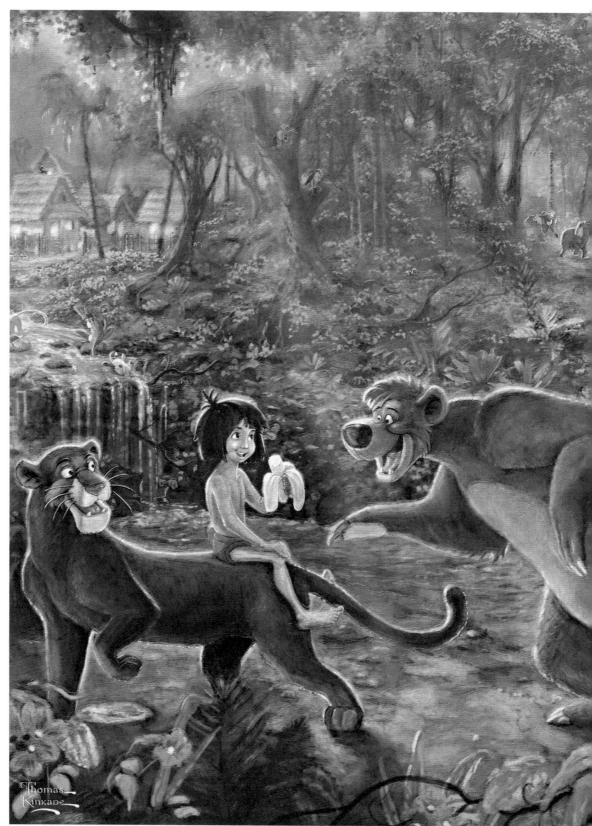

The Jungle Book

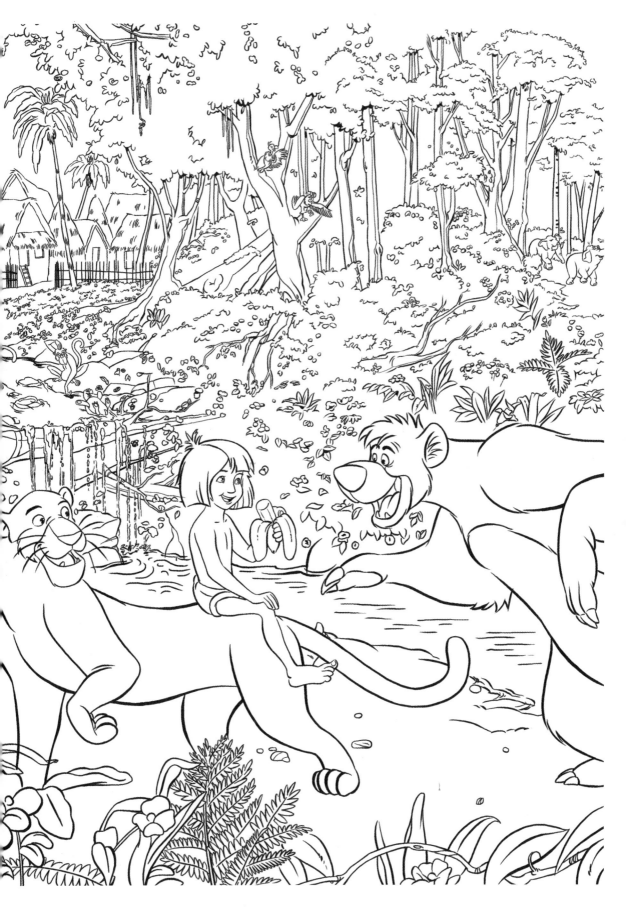

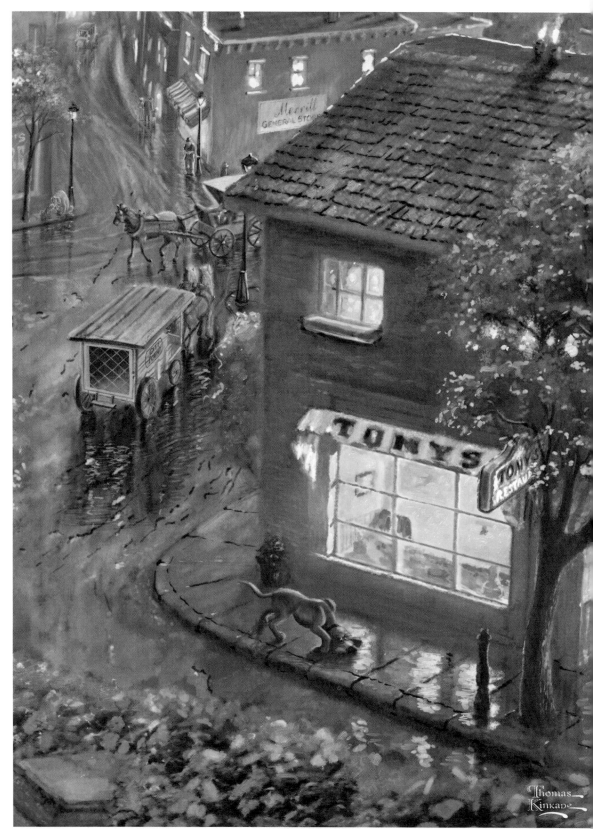

Lady and the Tramp

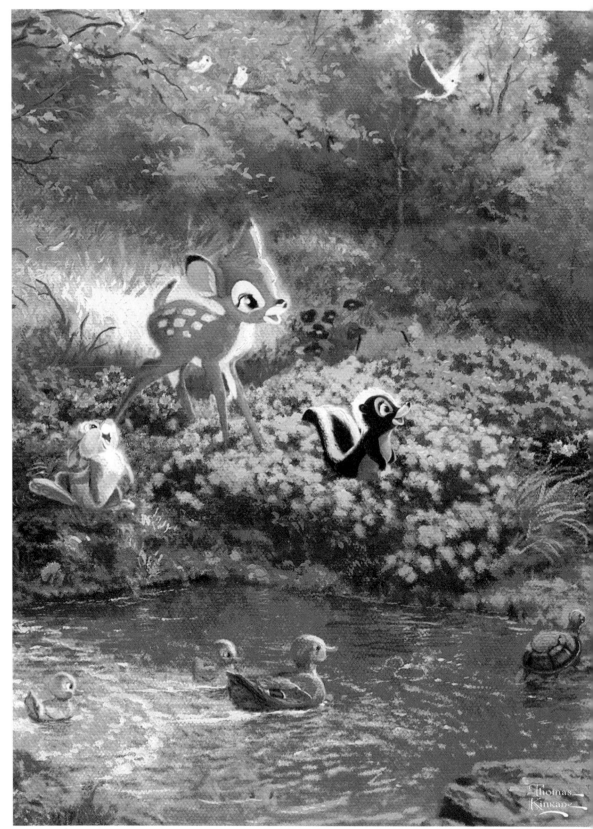

Bambi's First Year

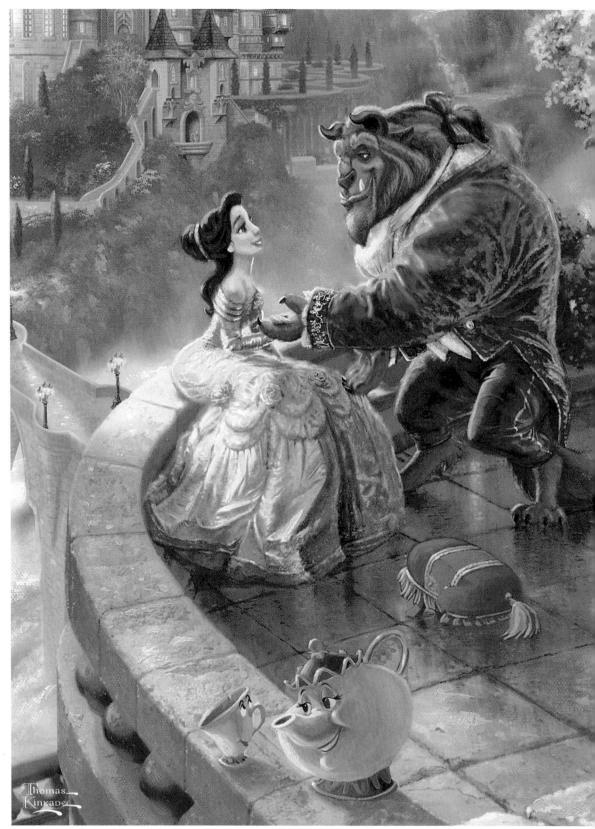

Beauty and the Beast Falling in Love

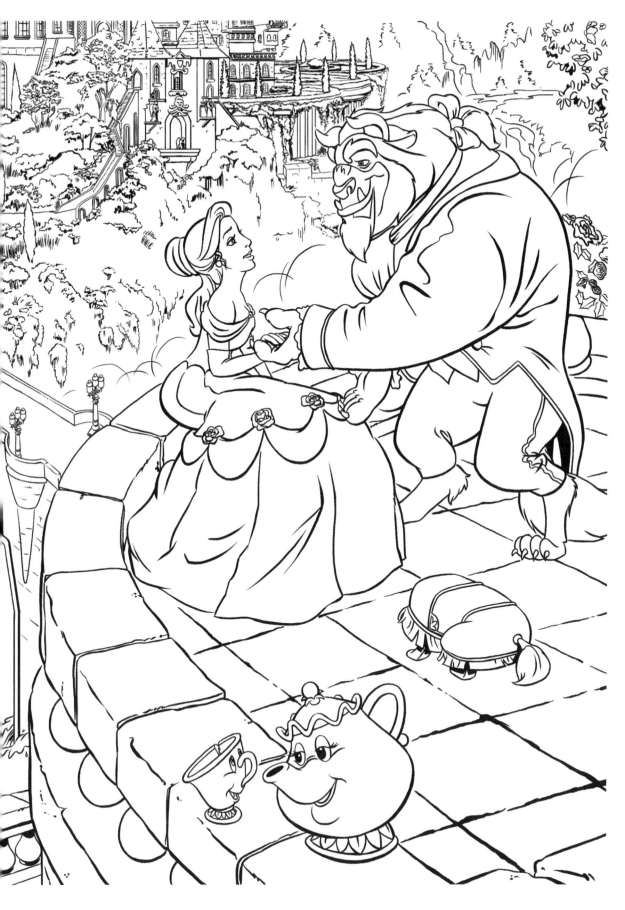

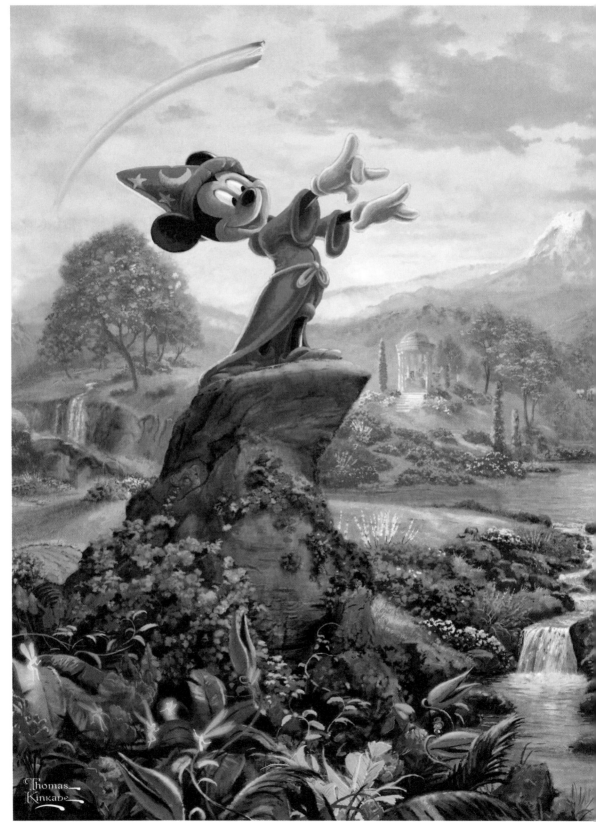

Fantasia

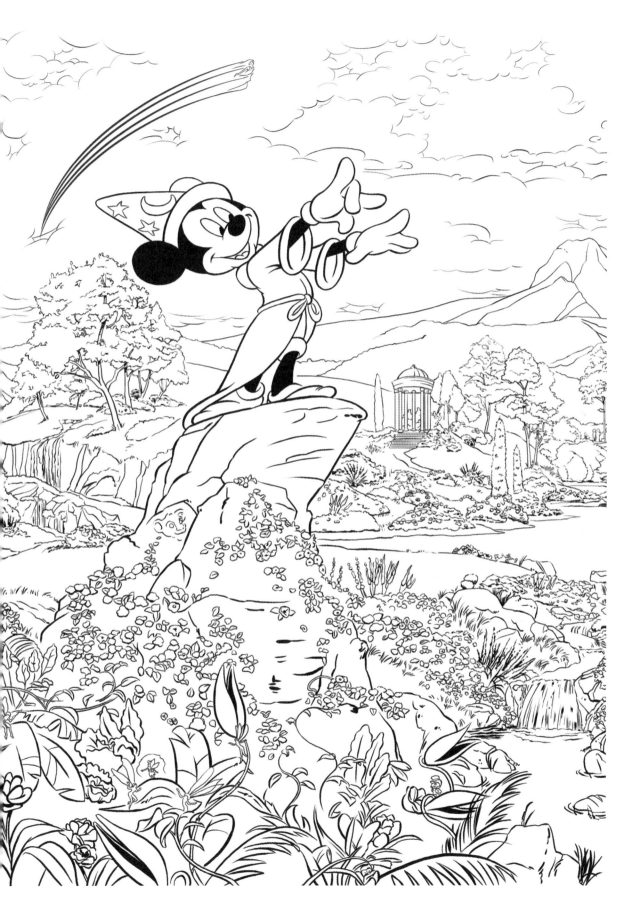

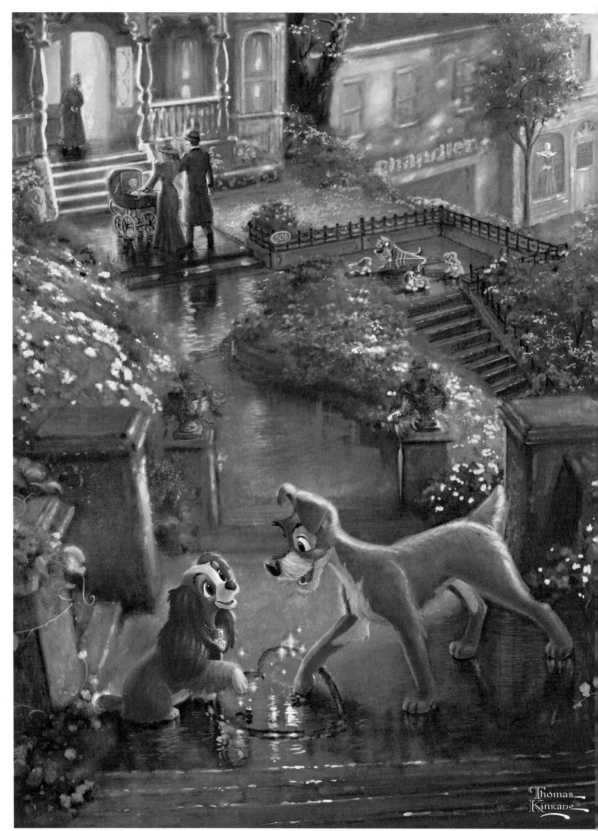

Lady and the Tramp

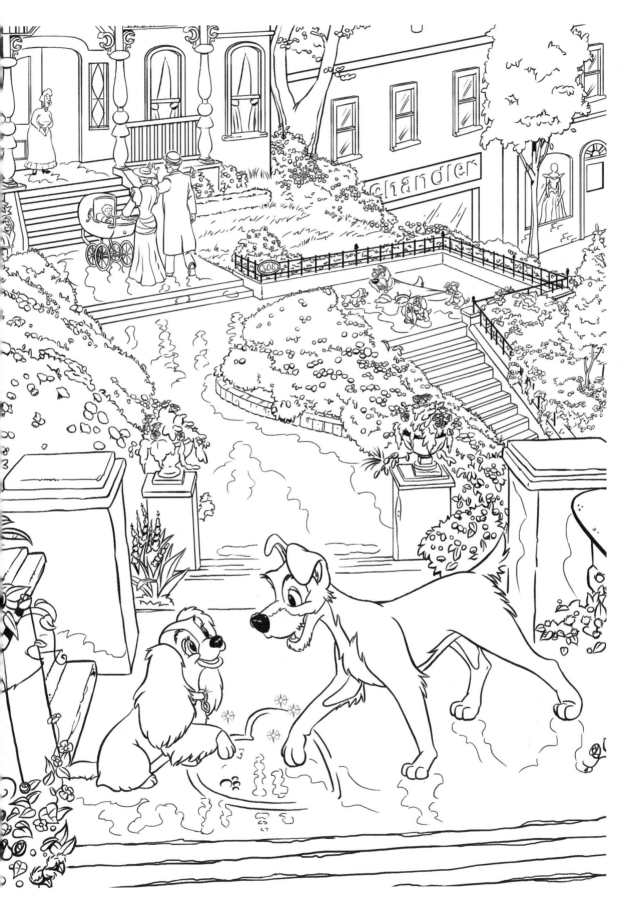

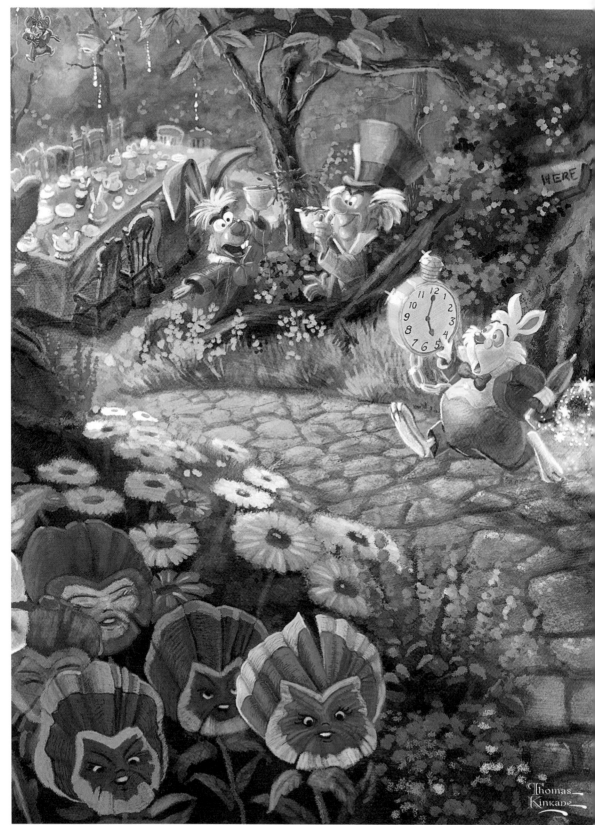

Alice in Wonderland

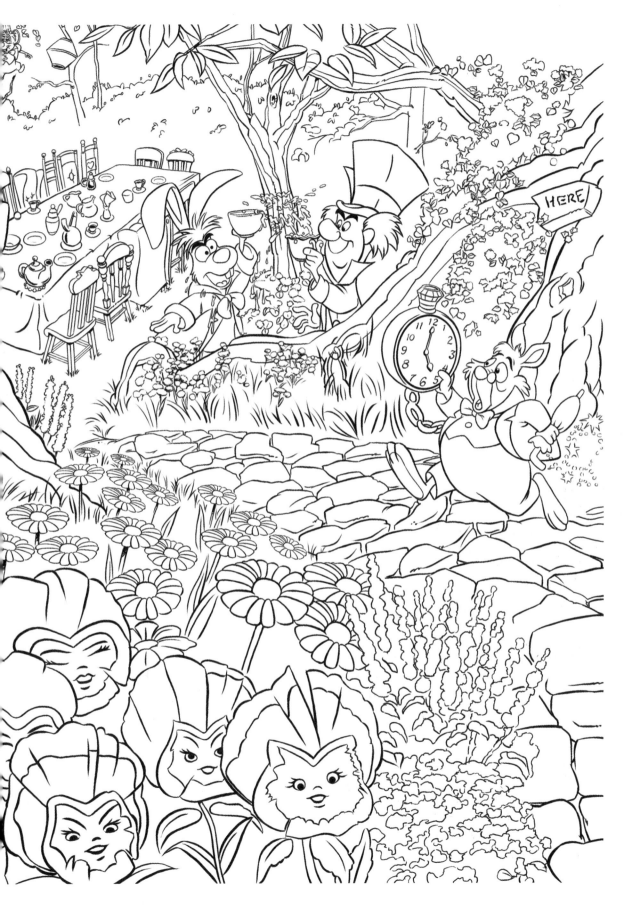

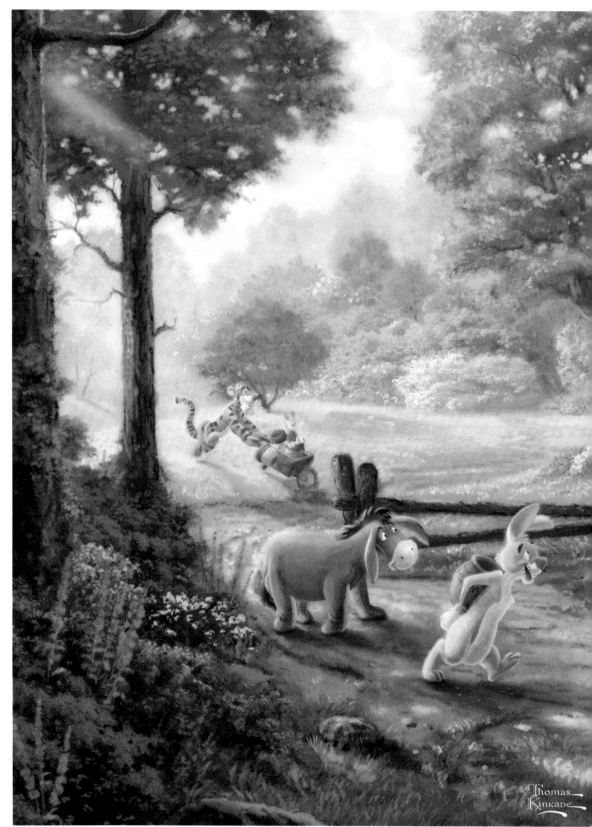

Winnie the Pooh II

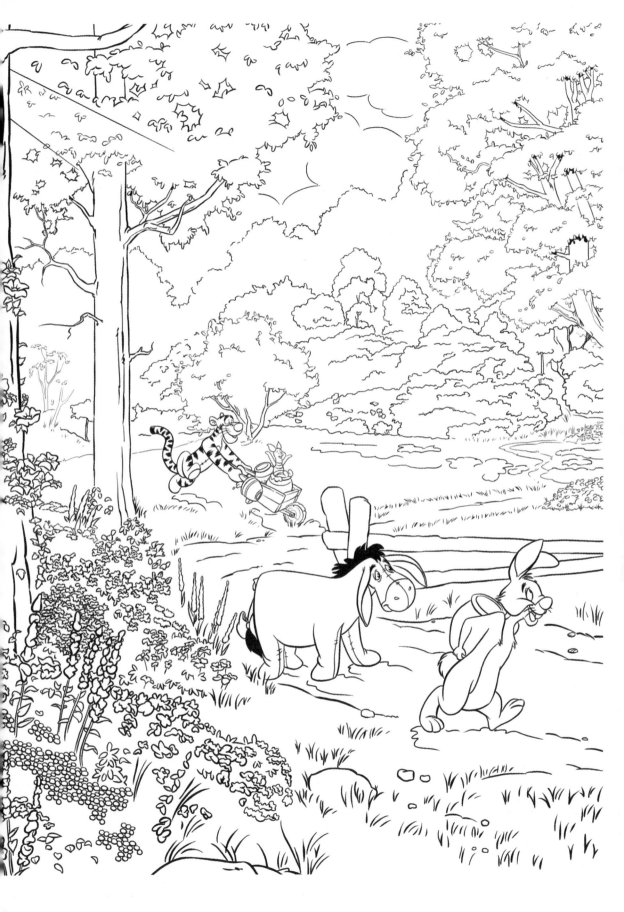

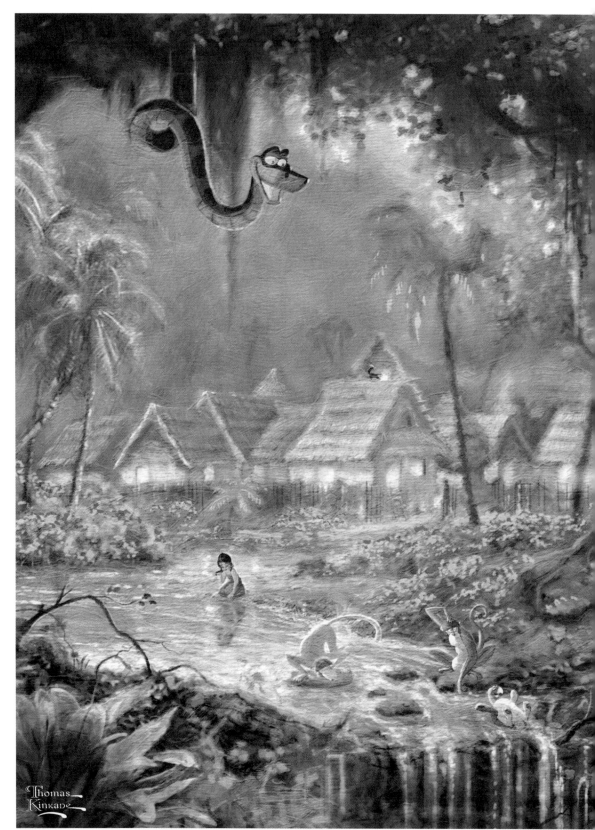

The Jungle Book

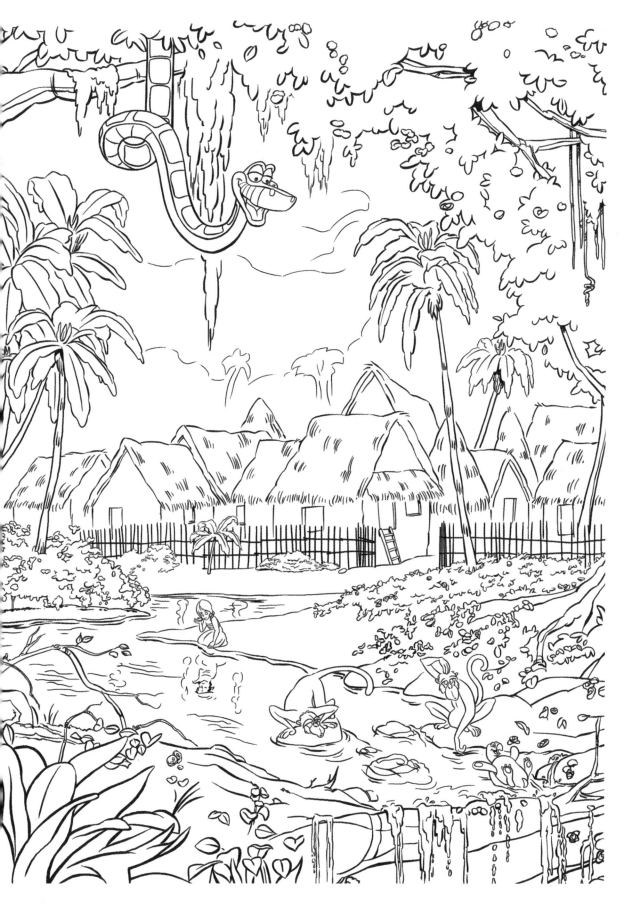

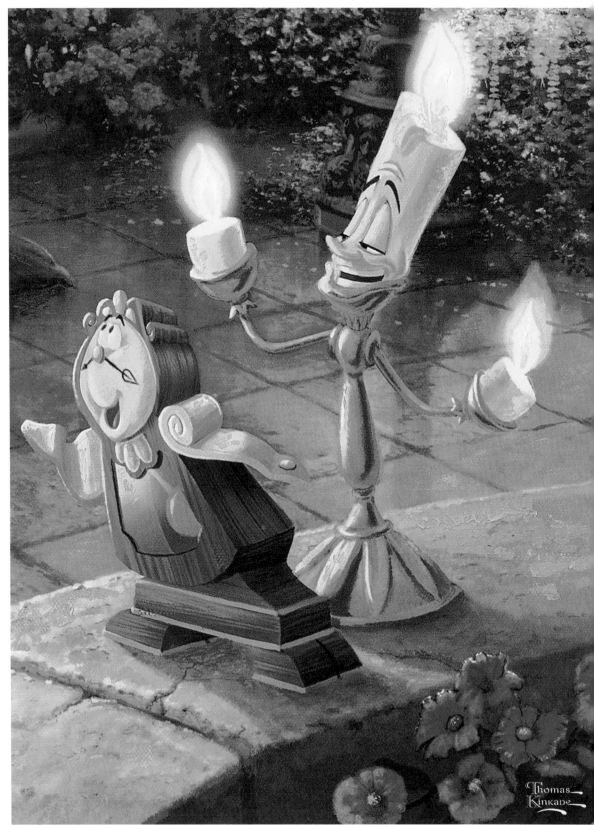

Beauty and the Beast Falling in Love

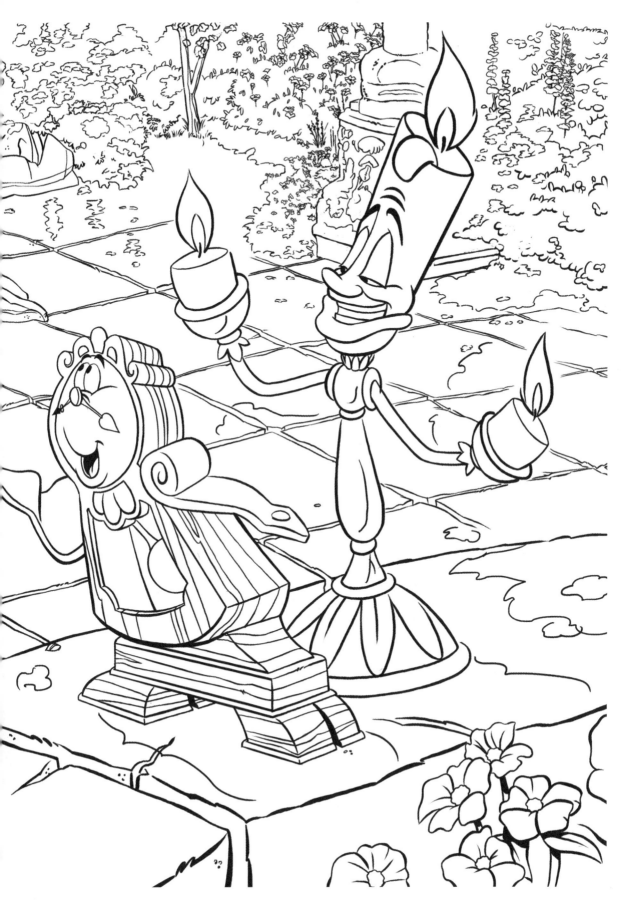

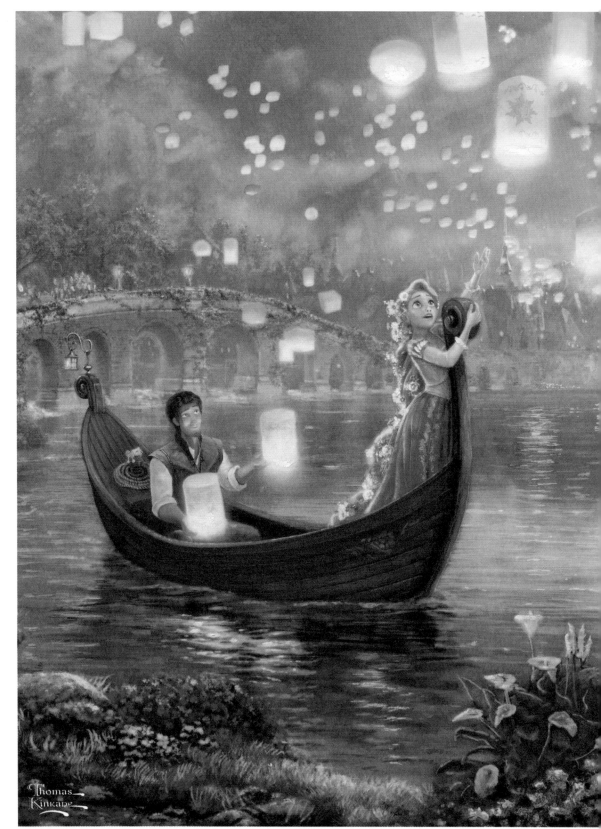

Tangled

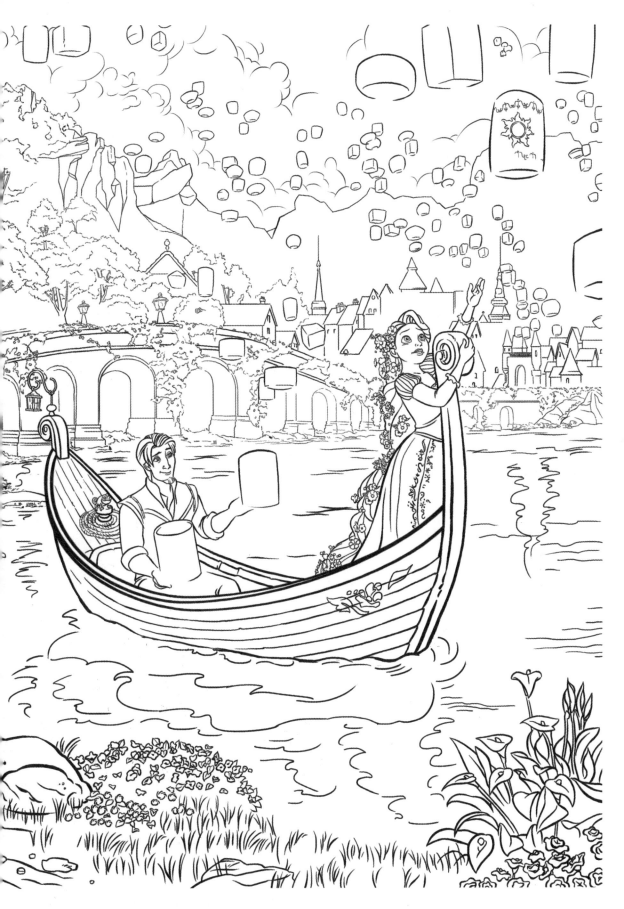

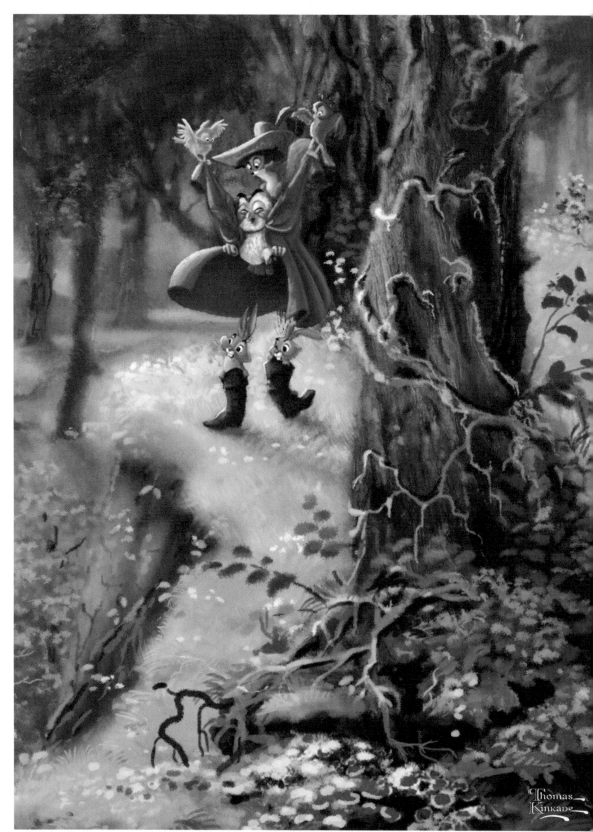

Sleeping Beauty

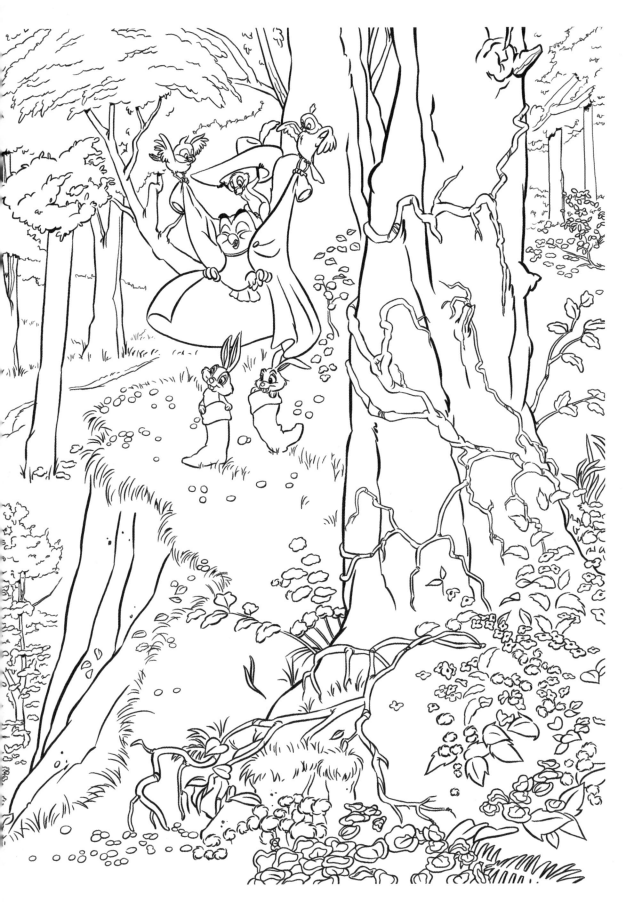

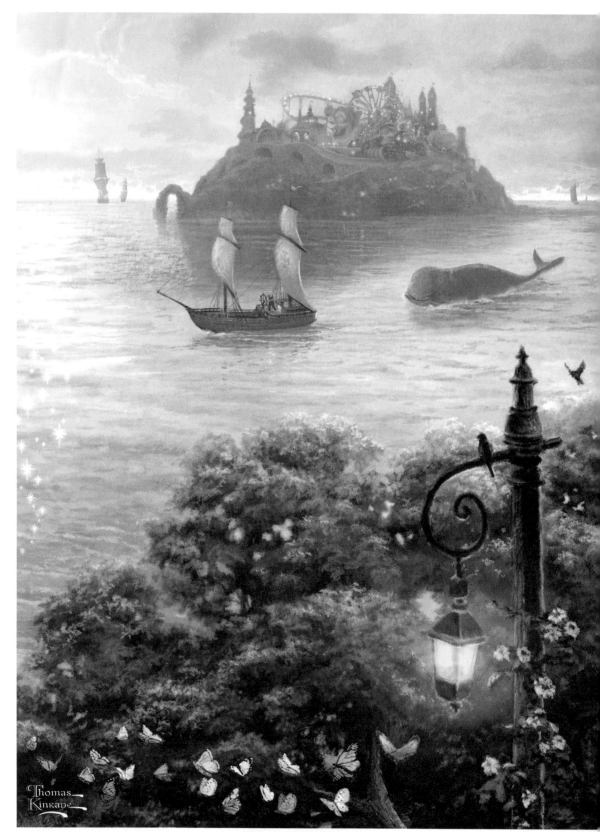

Pinocchio Wishes Upon a Star

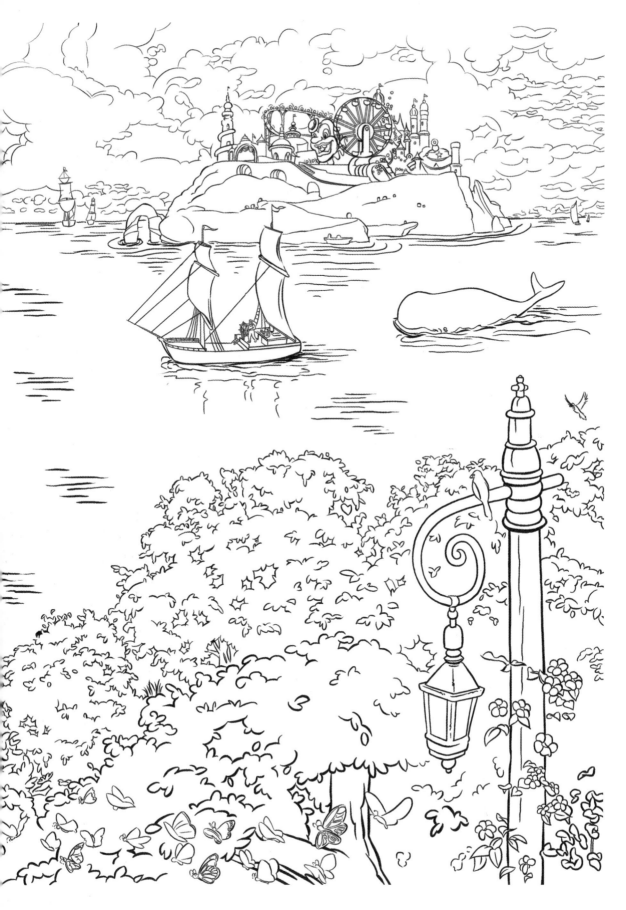

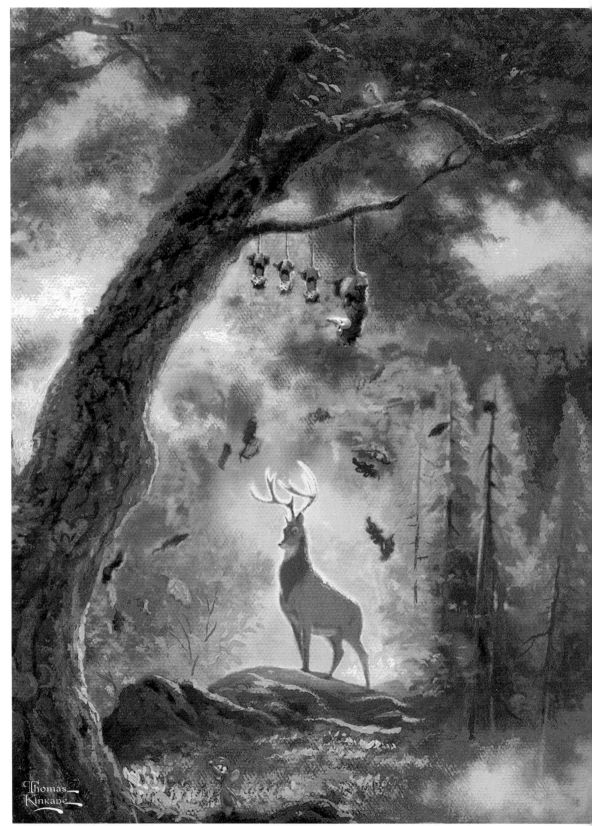

Bambi's First Year

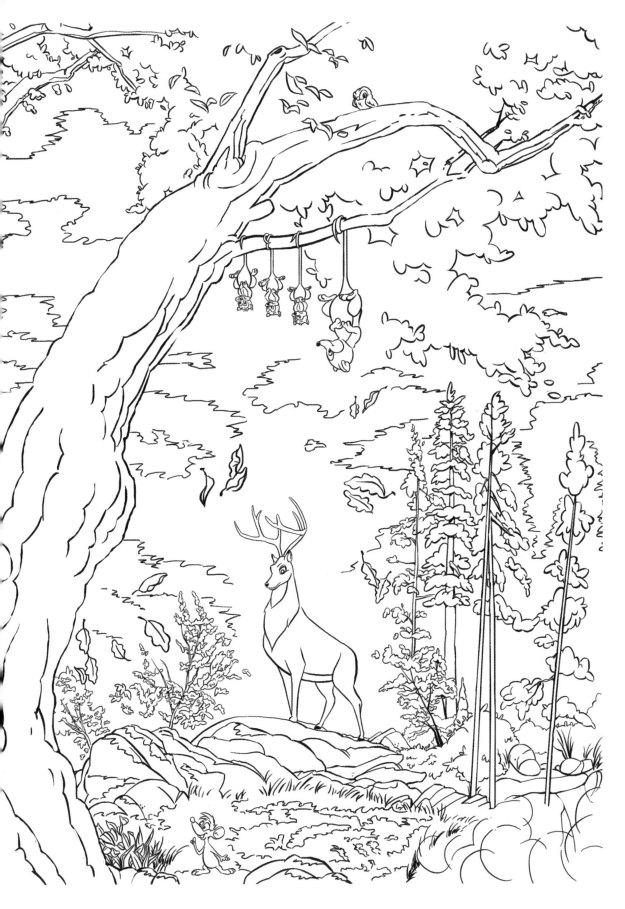

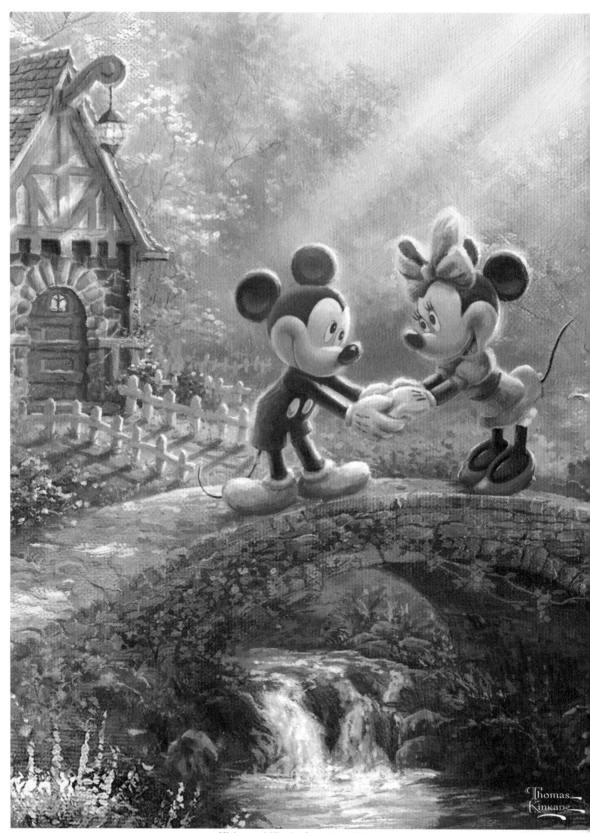

Mickey and Minnie–Sweetheart Bridge

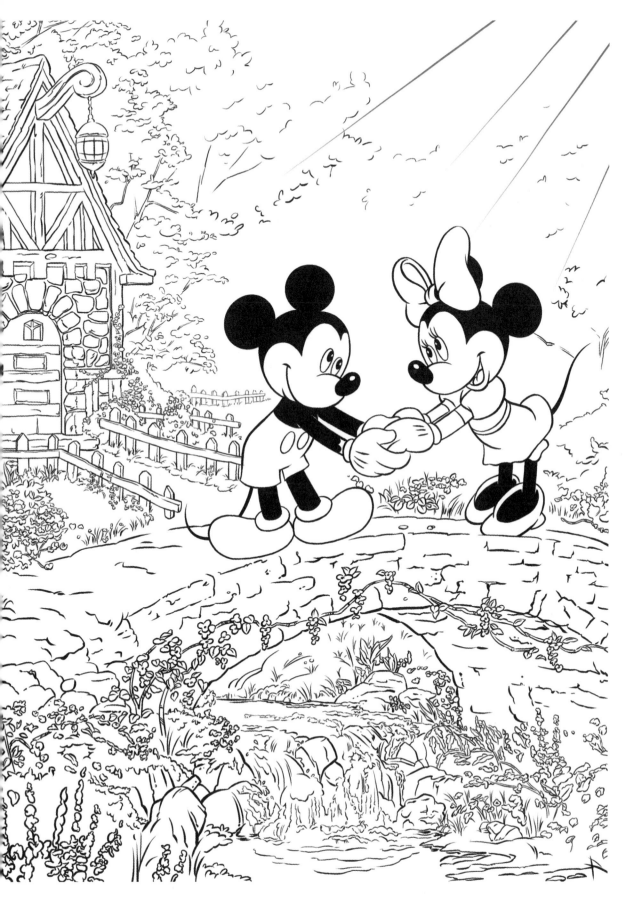

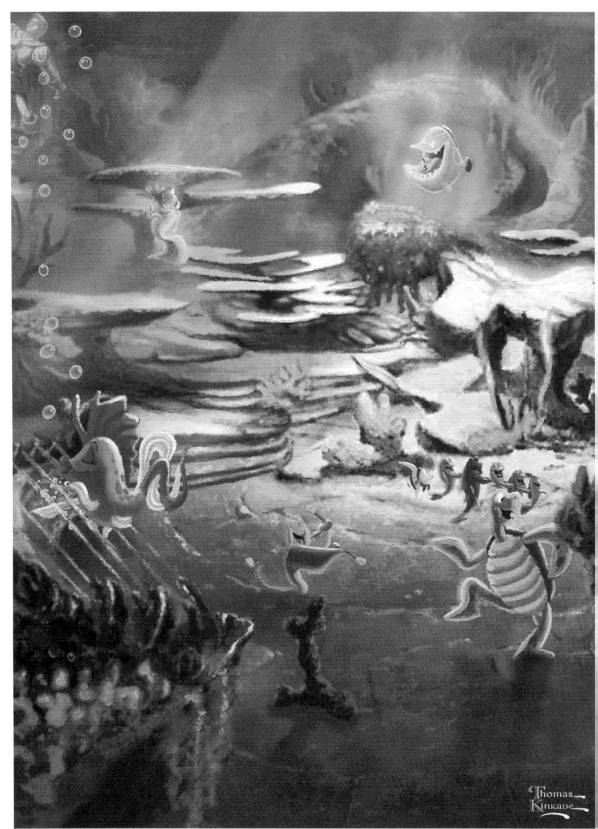

The Little Mermaid

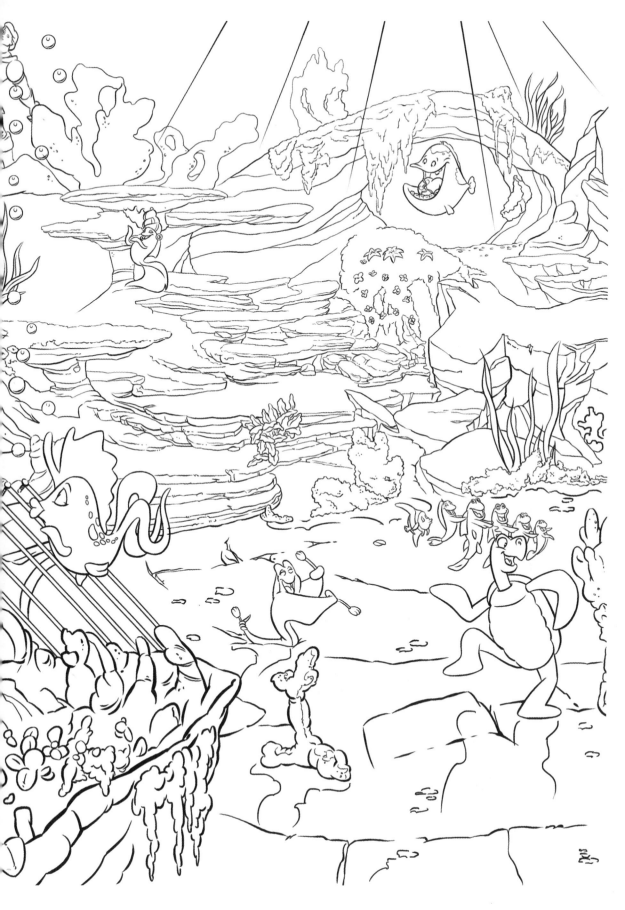

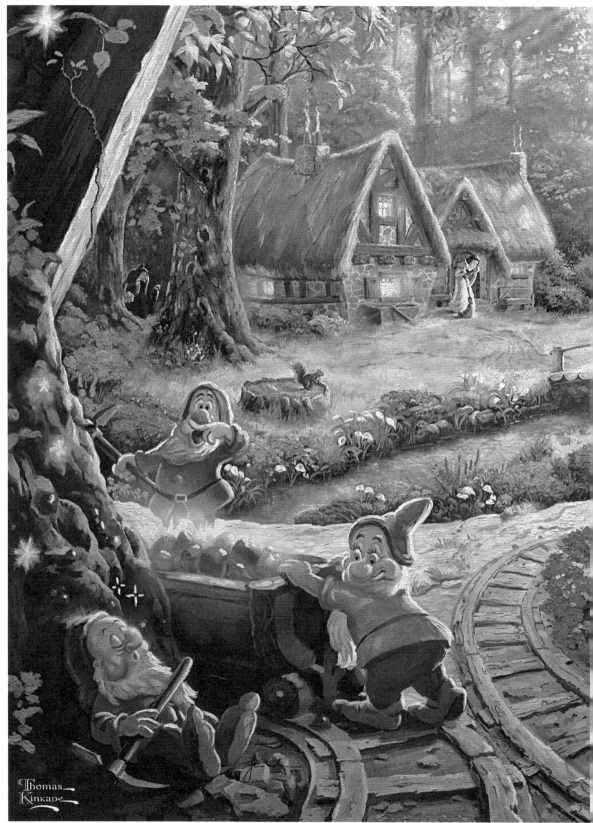

Snow White and the Seven Dwarfs

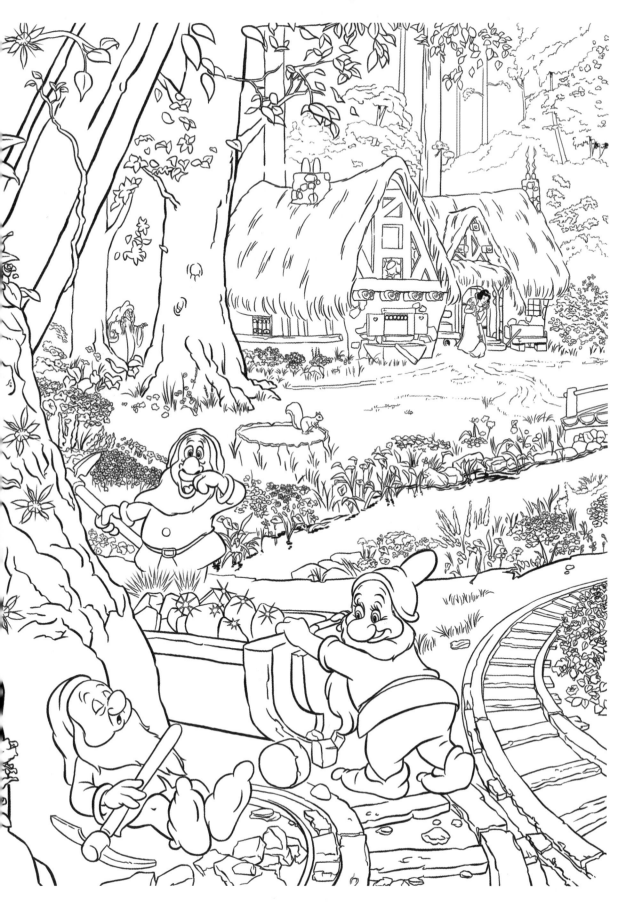

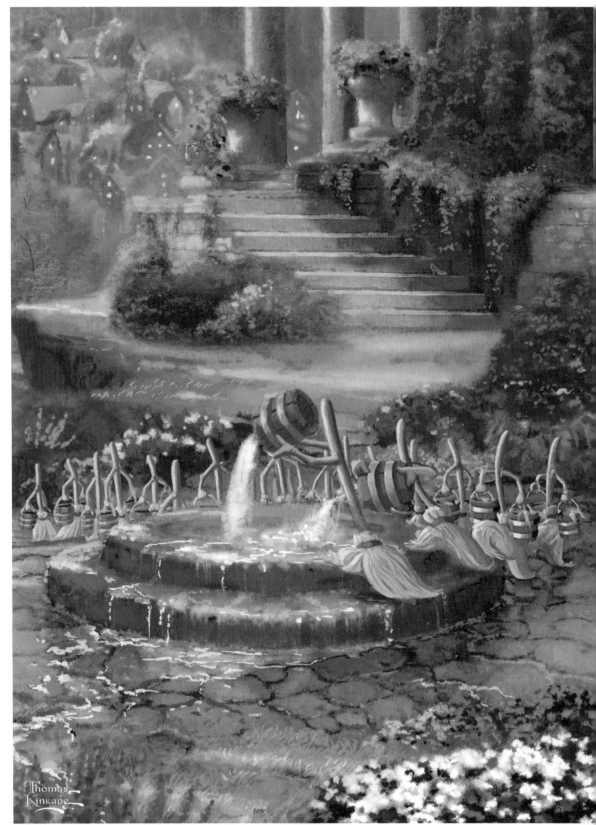

Fantasia

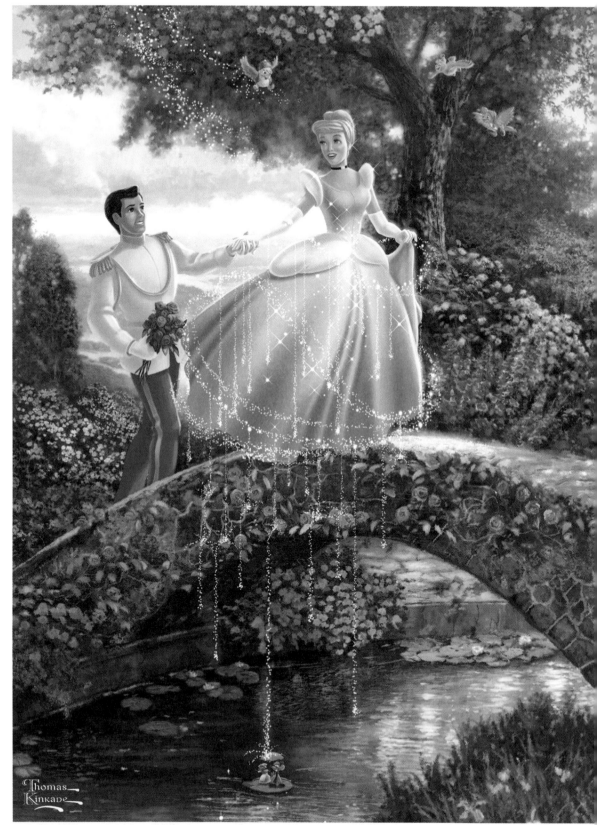

Cinderella Wishes Upon a Dream

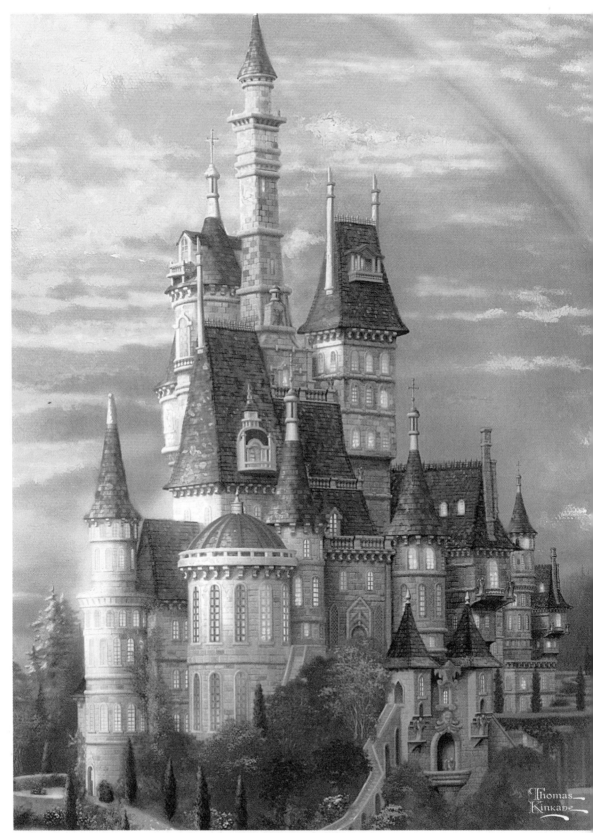

Beauty and the Beast Falling in Love

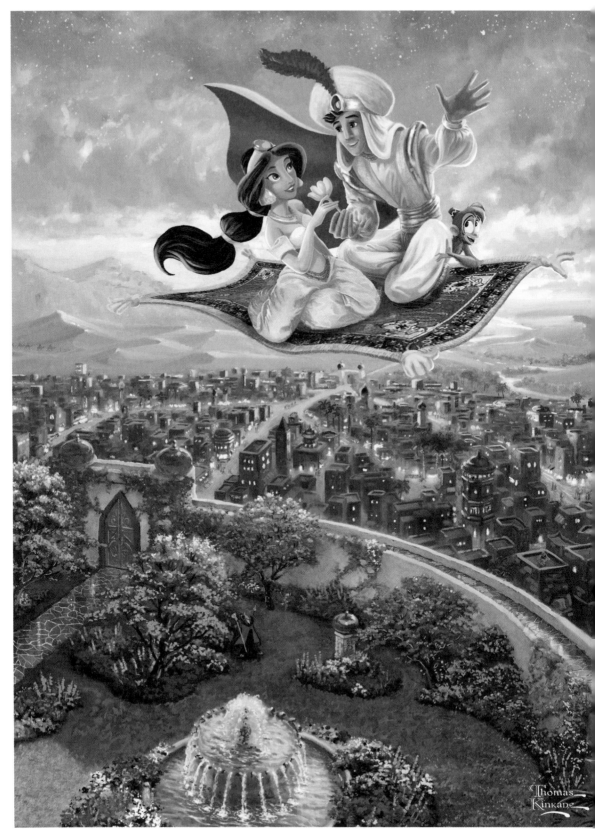

Aladdin

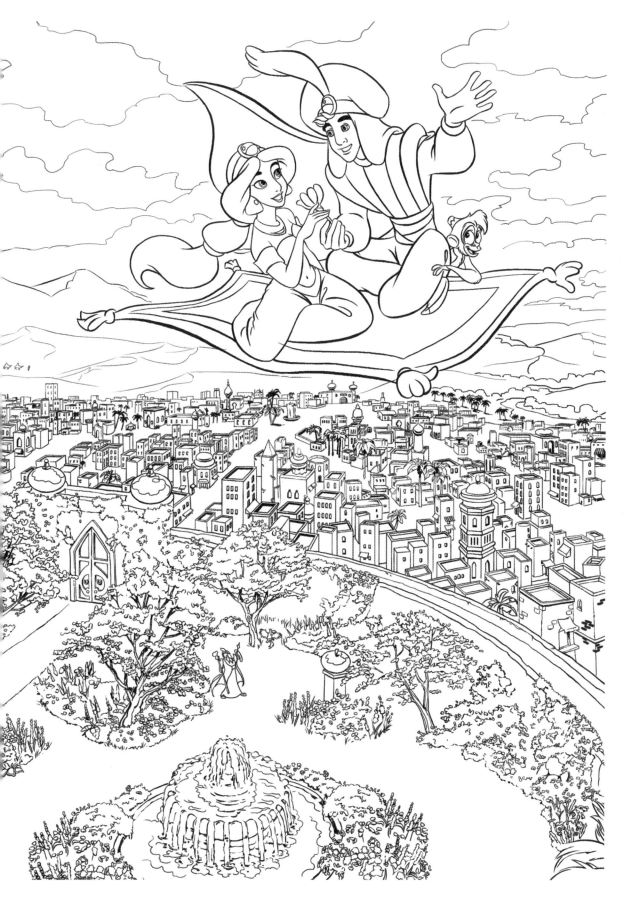

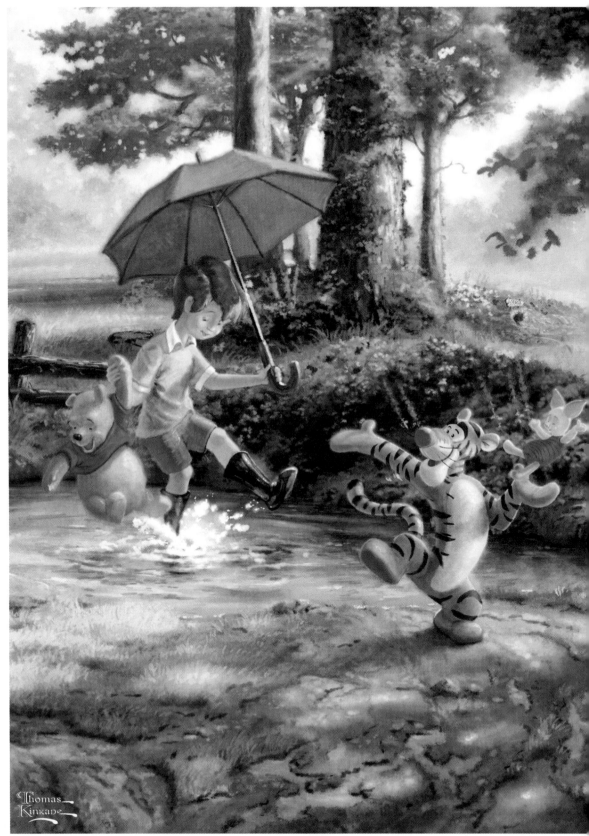

Winnie the Pooh I

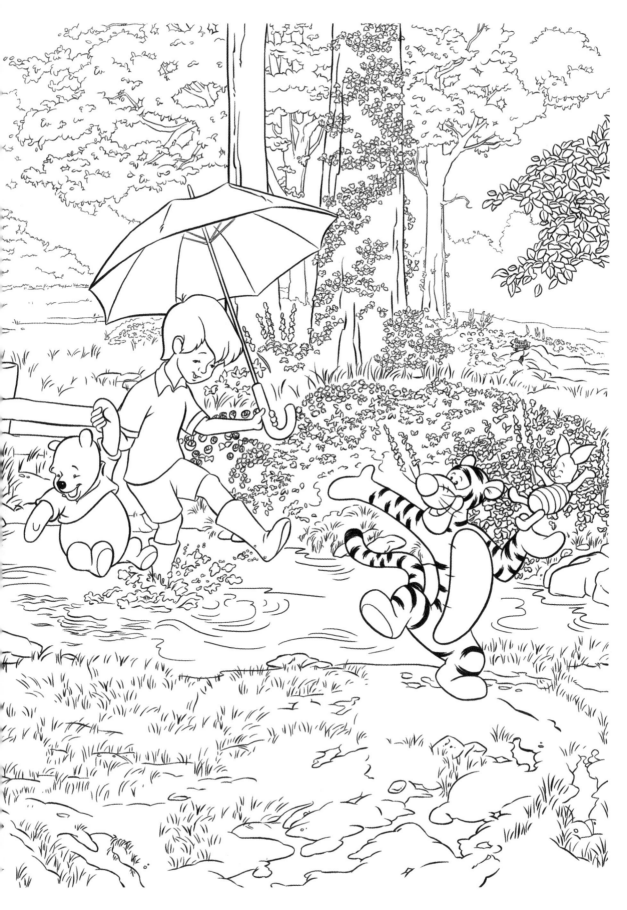

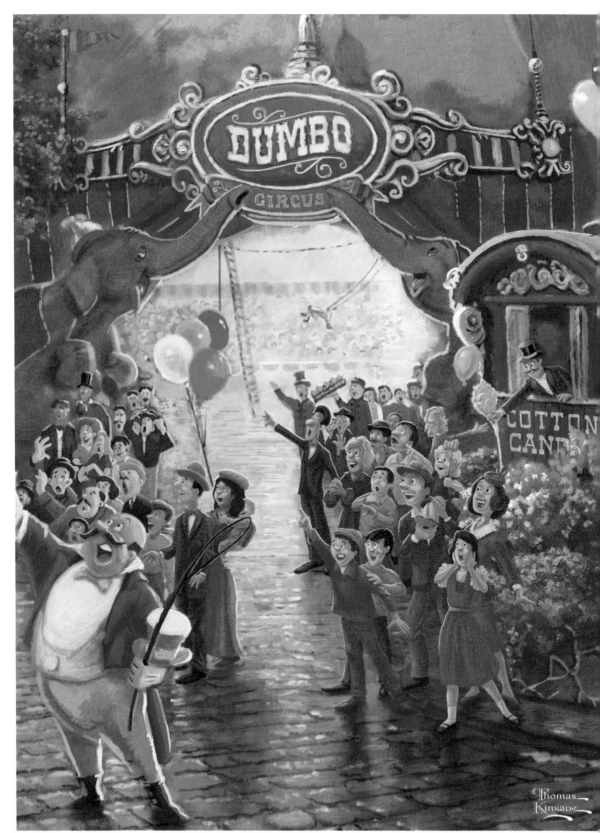

Dumbo

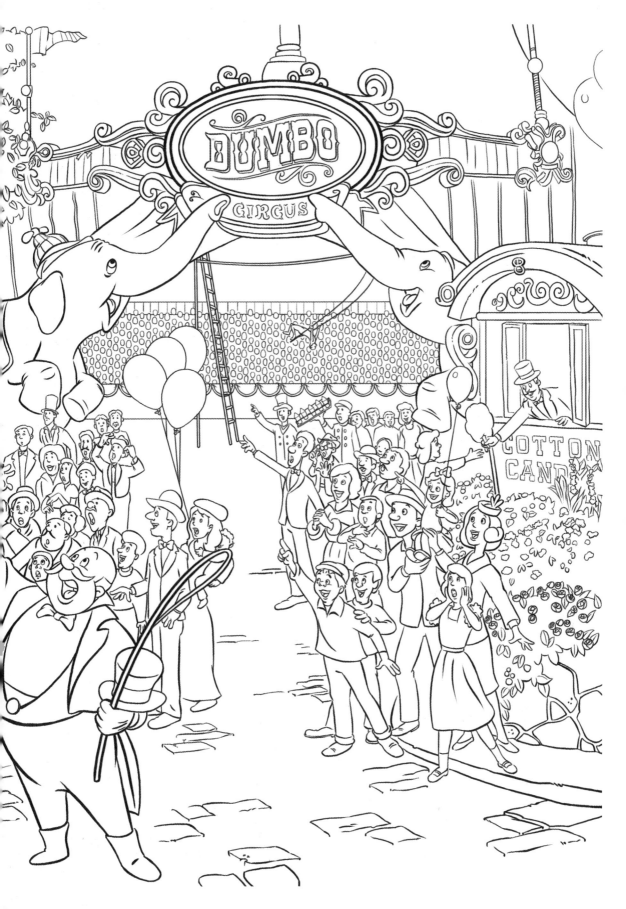

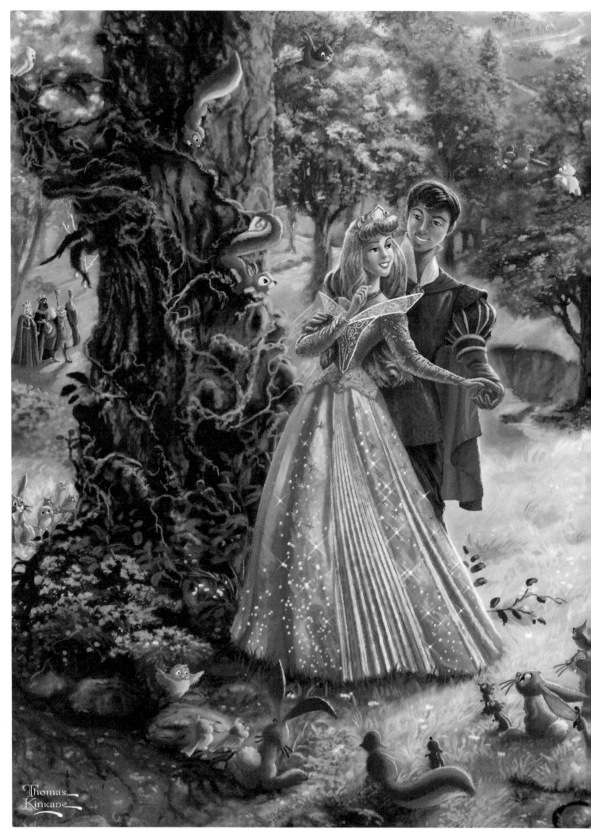

Sleeping Beauty

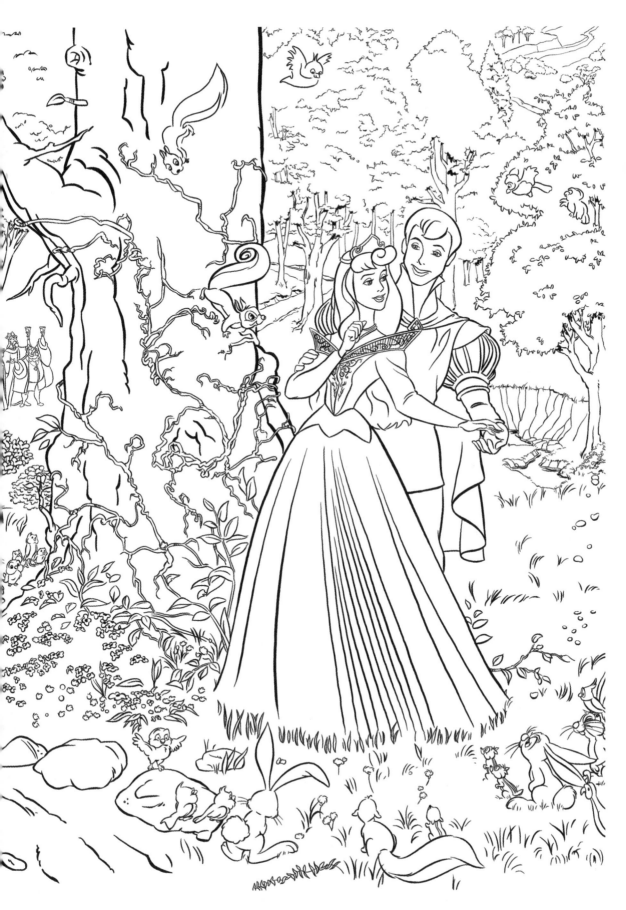

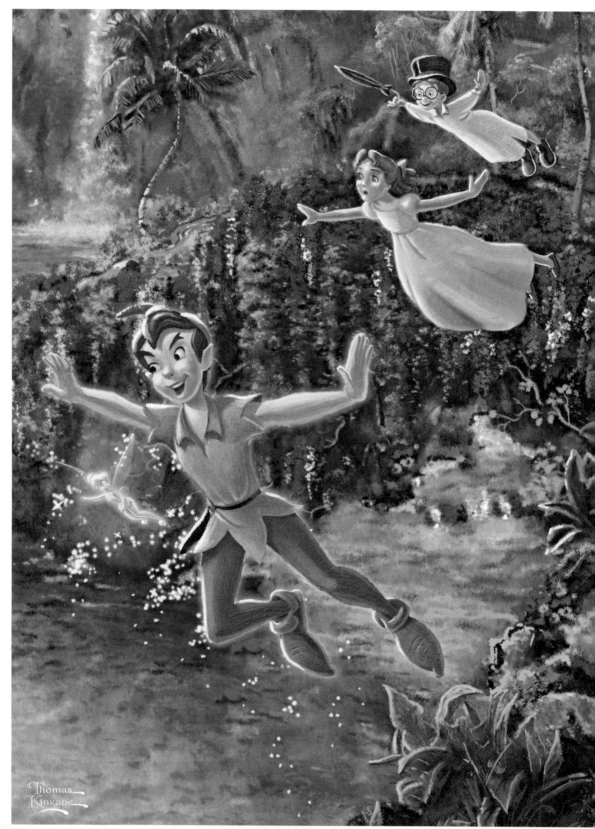

Peter Pan's Never Land

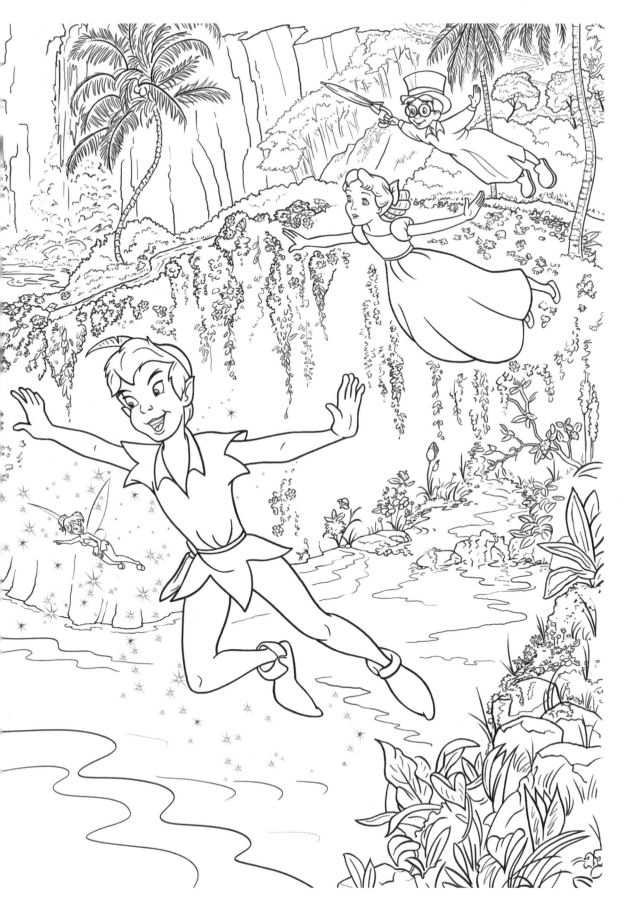

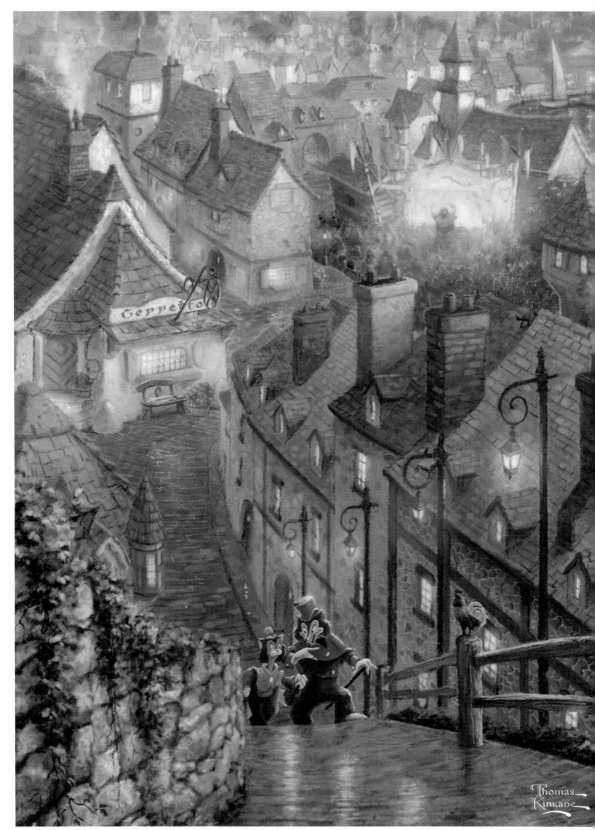

Pinocchio Wishes Upon a Star

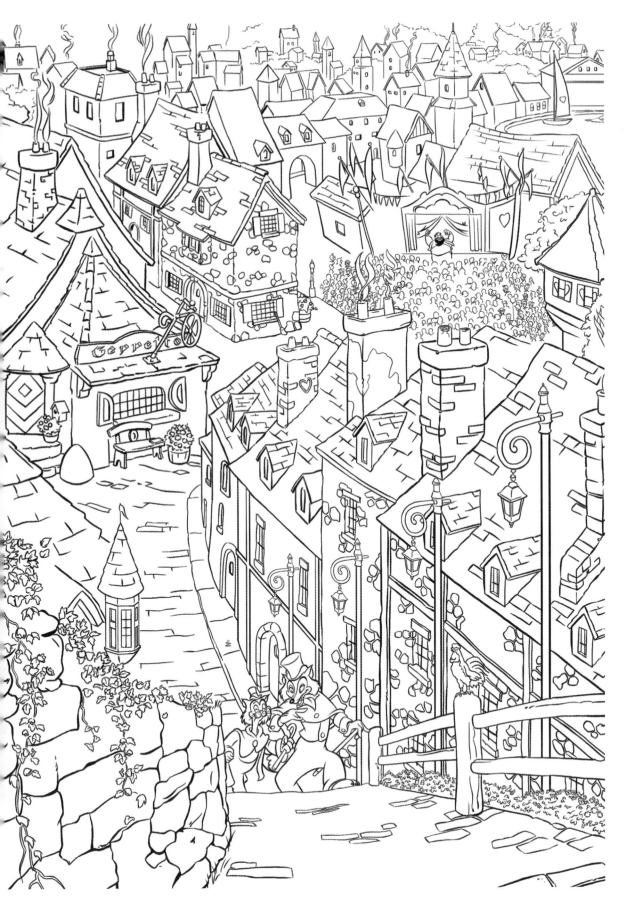

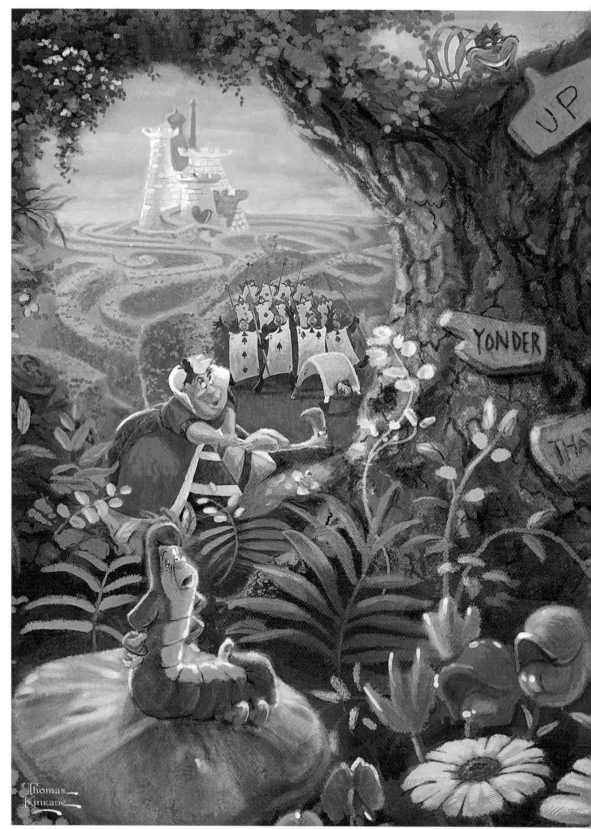

Alice in Wonderland

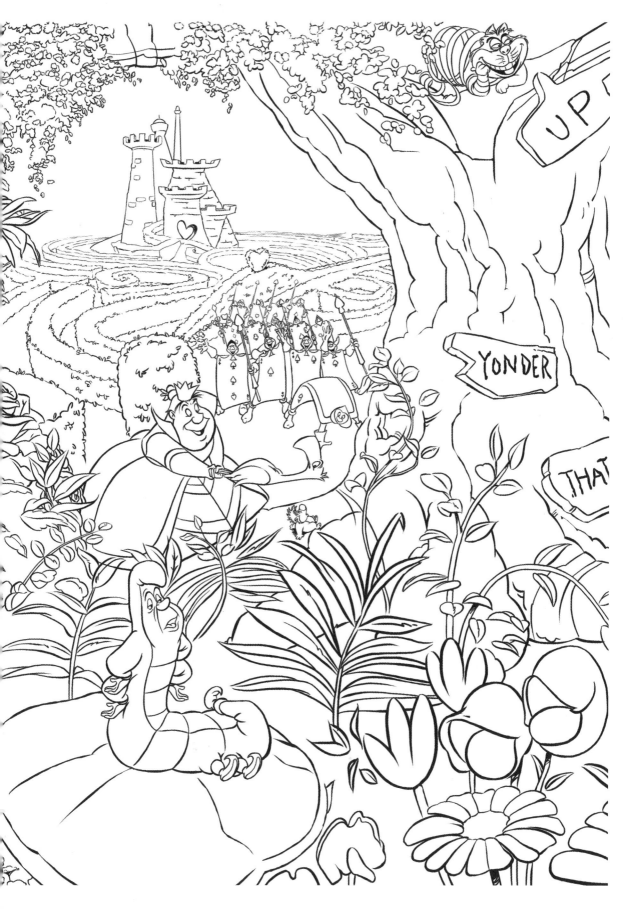

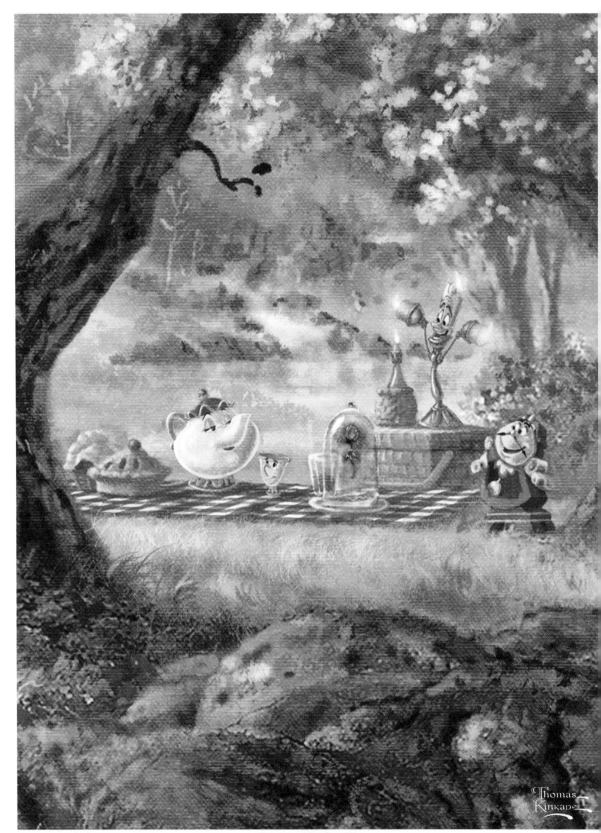

Beauty and the Beast II

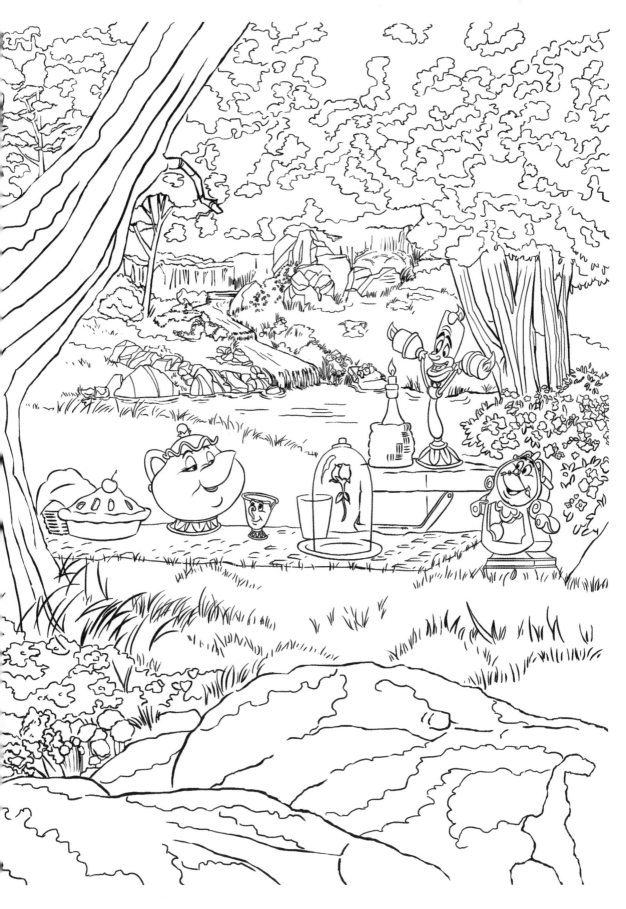

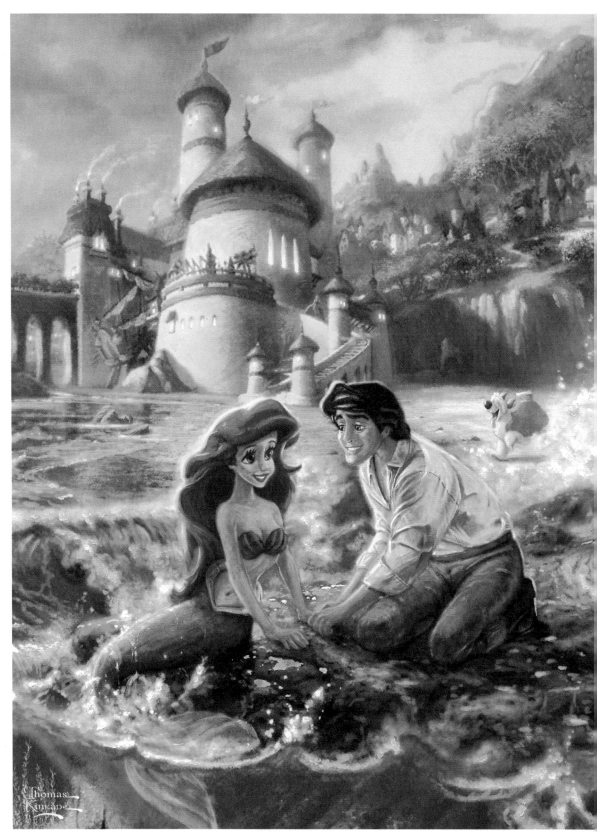

The Little Mermaid

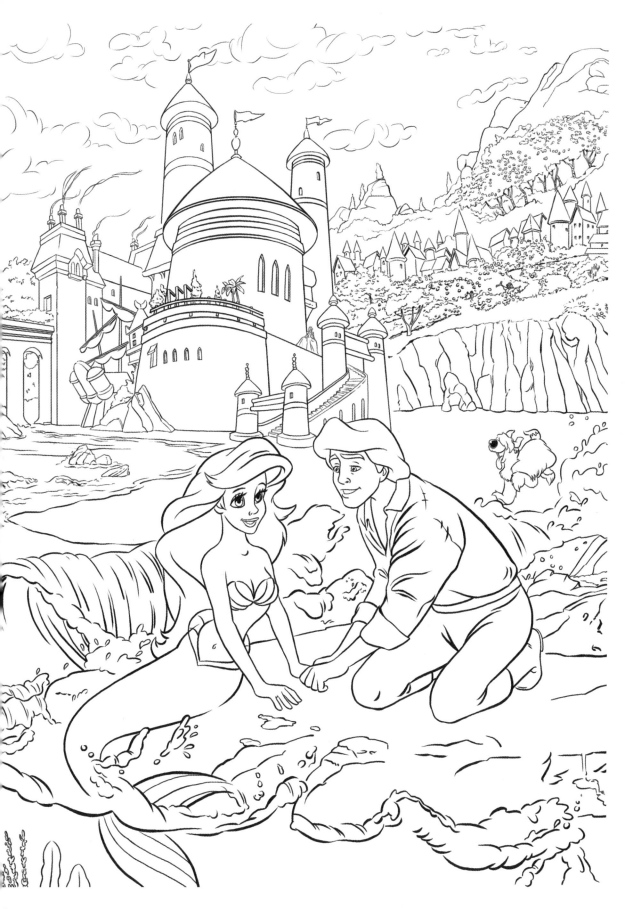

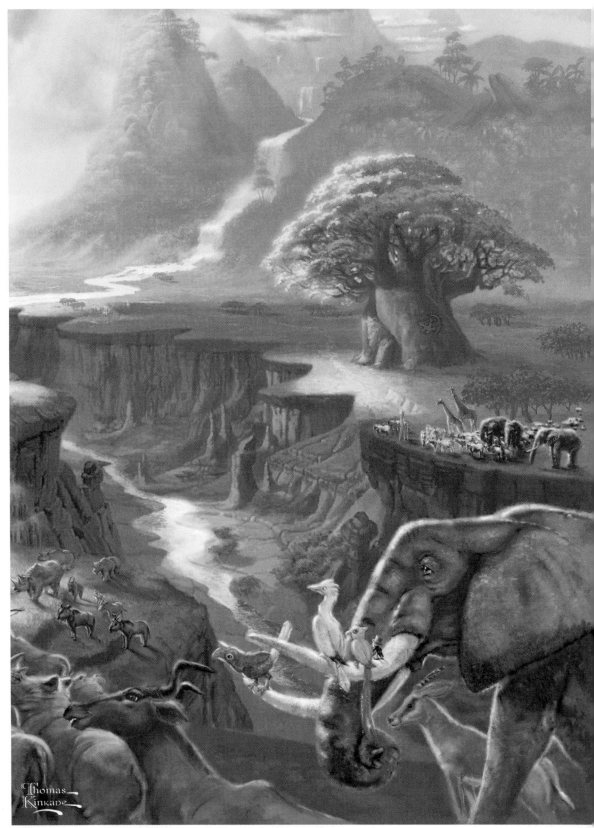

The Lion King

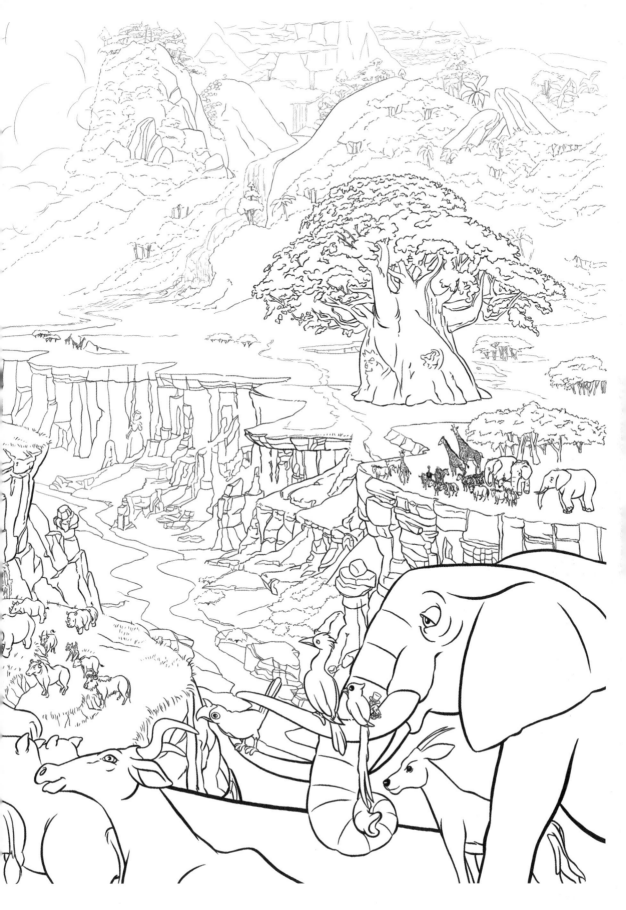

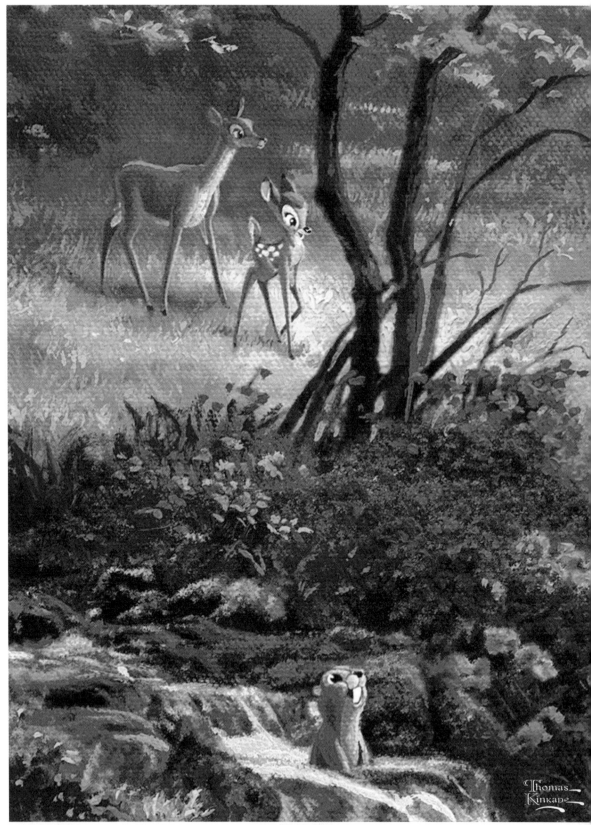

Bambi's First Year

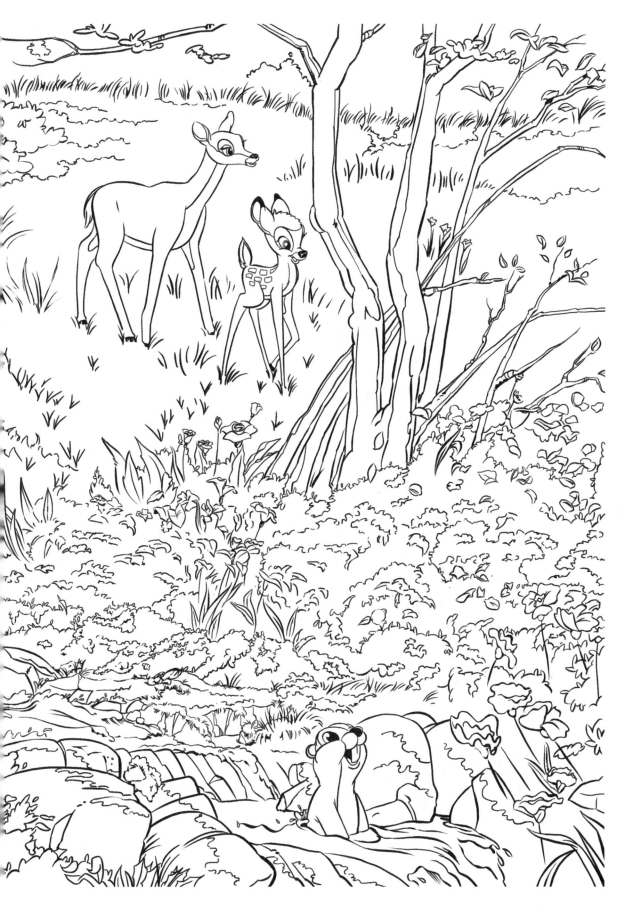

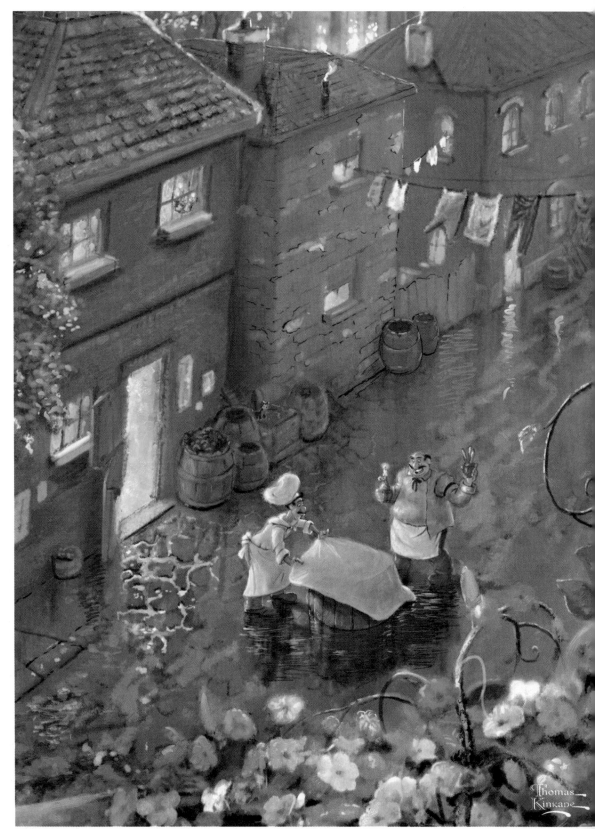

Lady and the Tramp

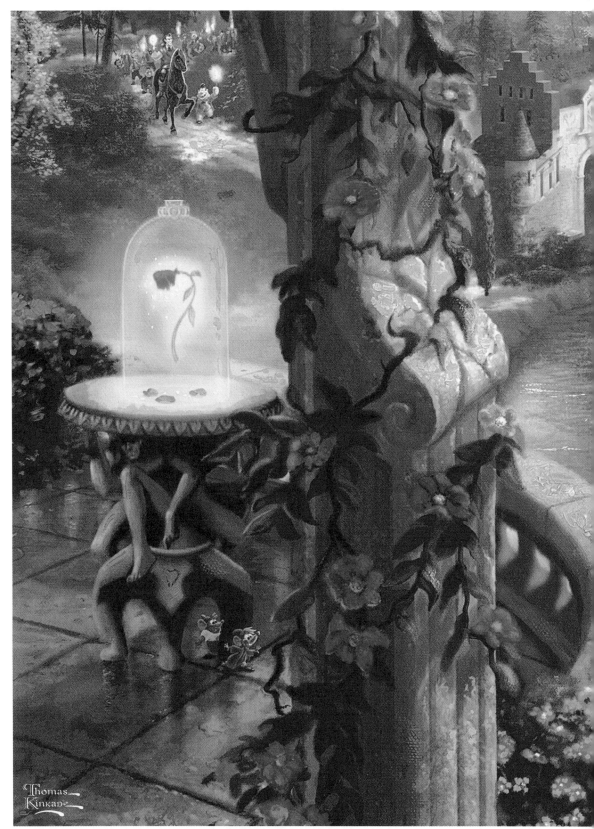

Beauty and the Beast Falling in Love

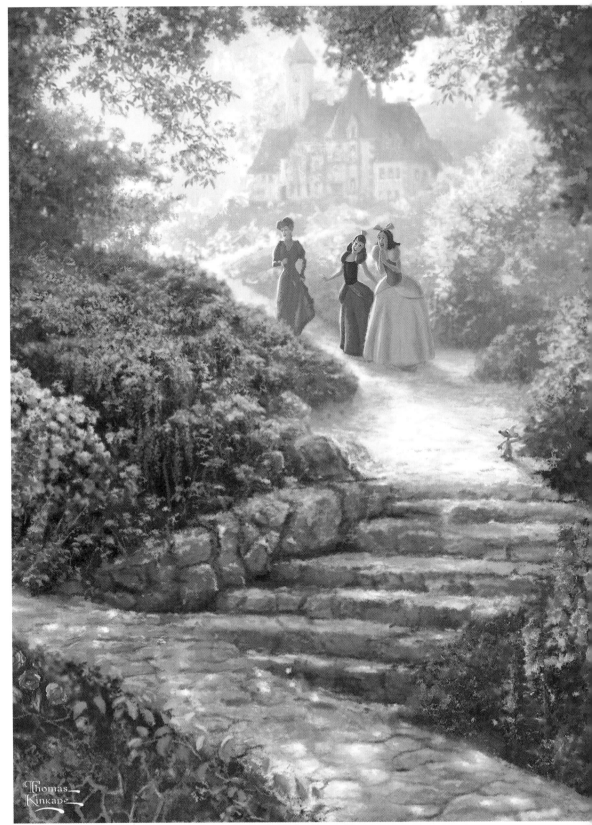

Cinderella Wishes Upon a Dream

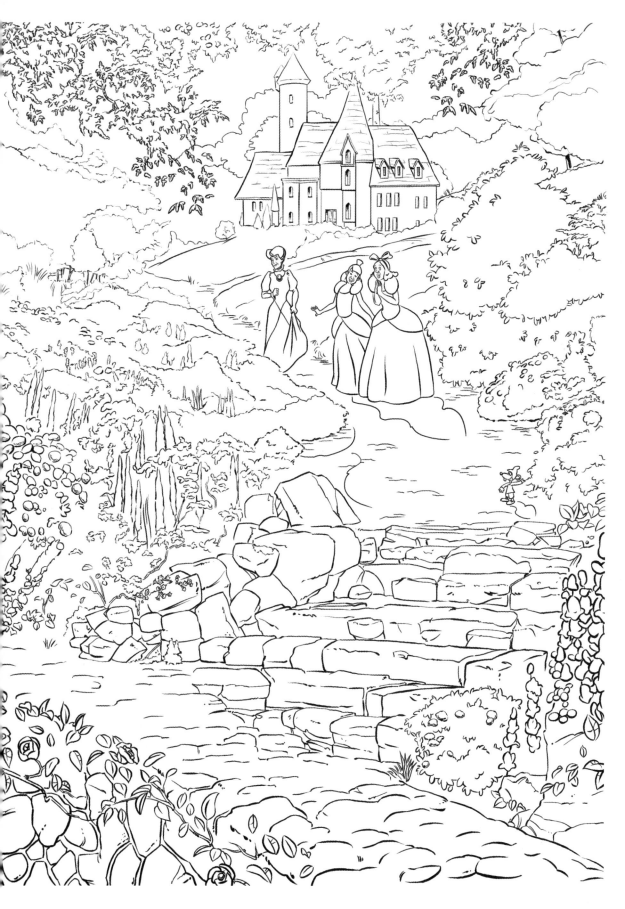

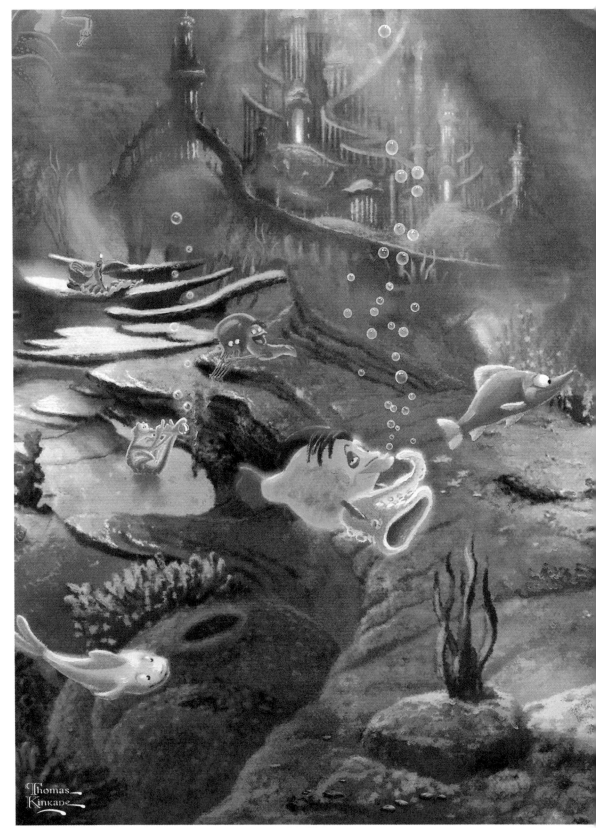

The Little Mermaid

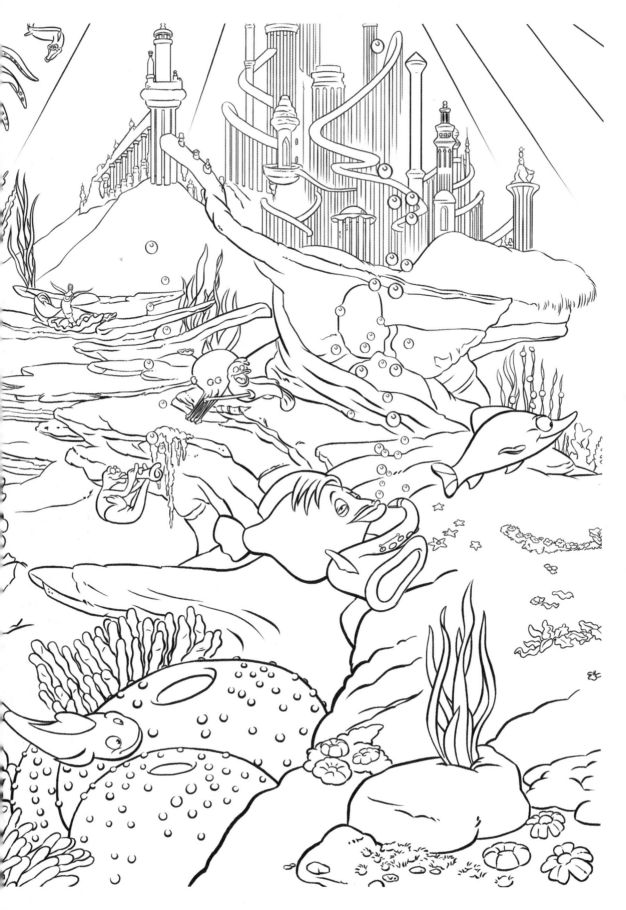

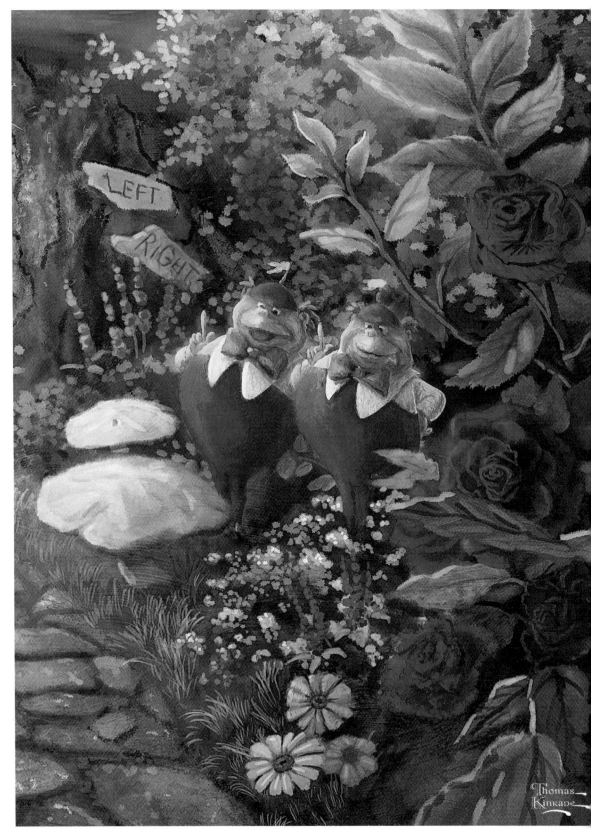

Alice in Wonderland

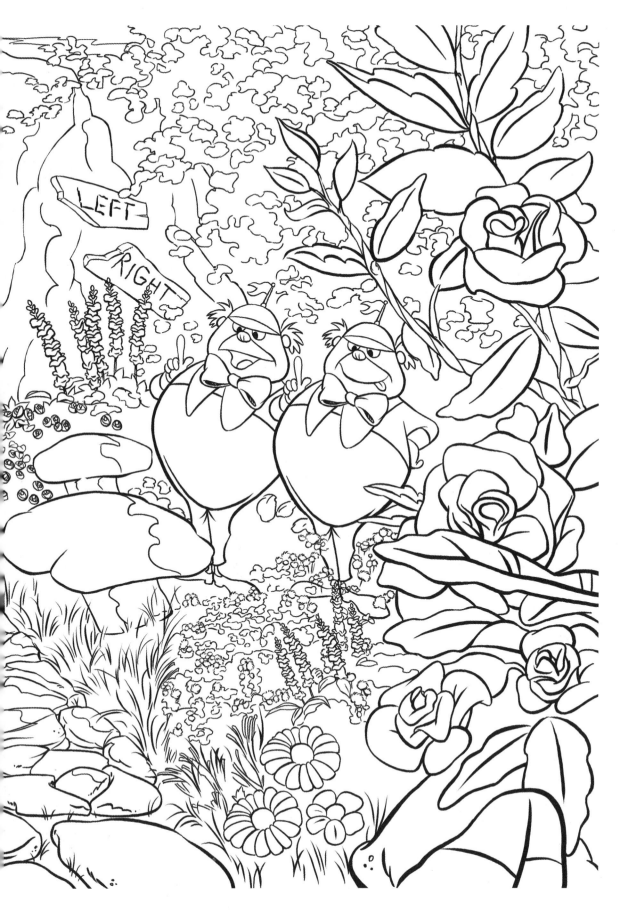

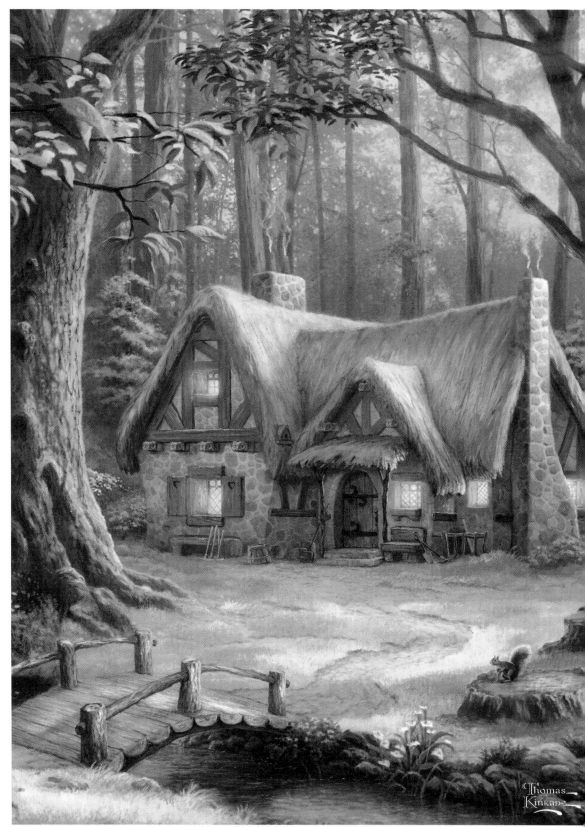

Snow White Discovers the Cottage

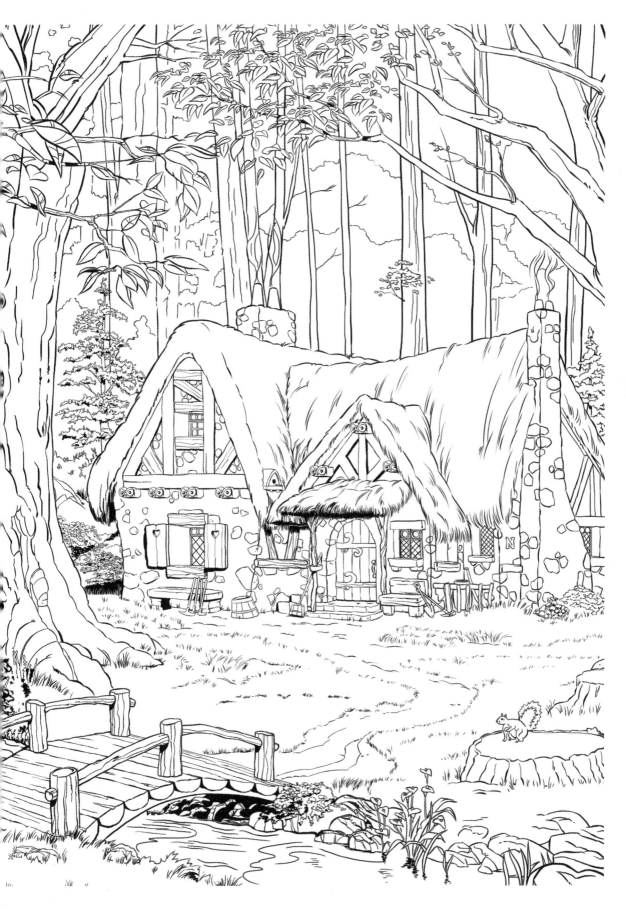

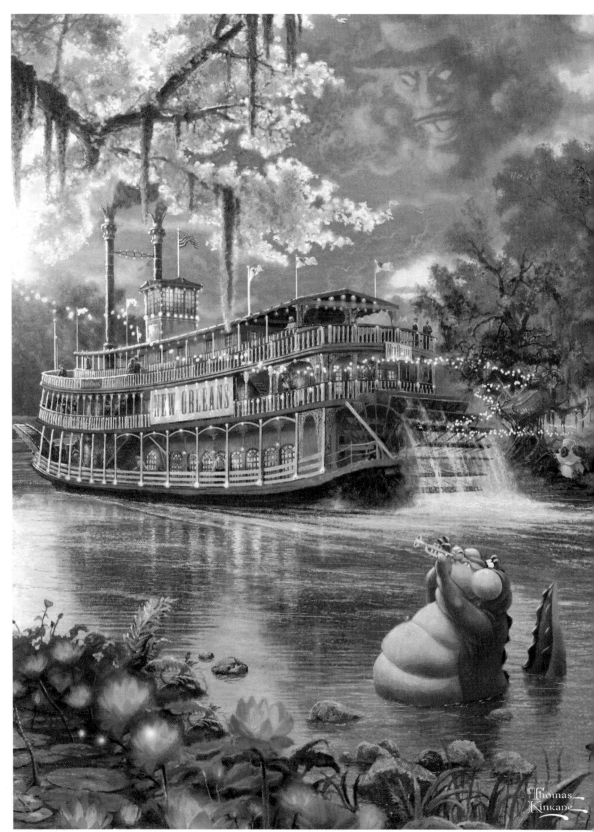

The Princess and the Frog

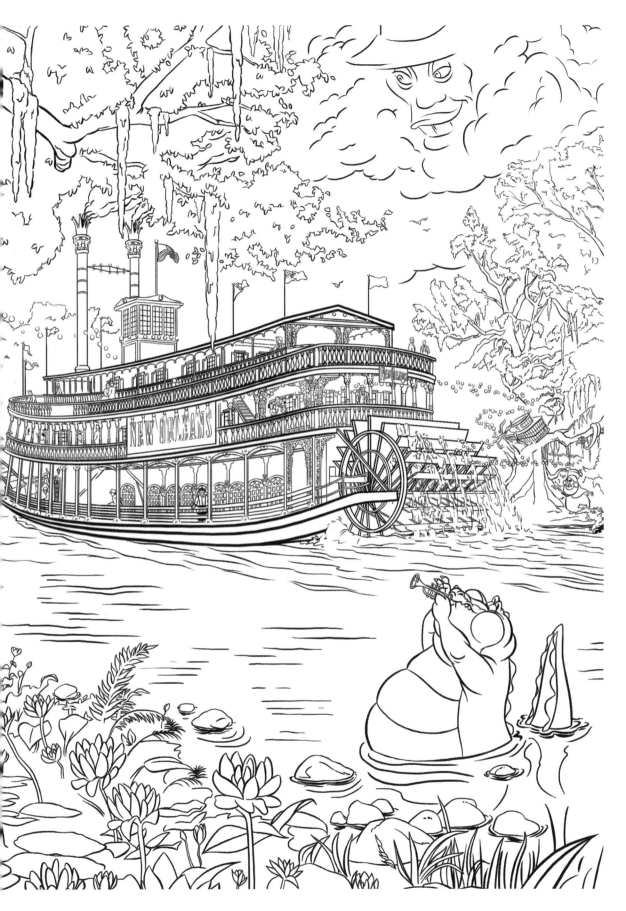

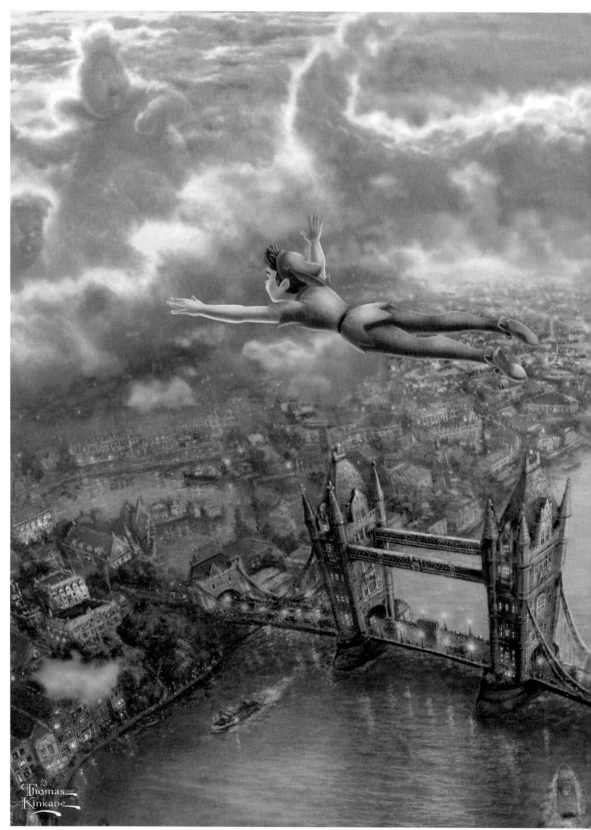

Tinker Bell and Peter Pan Fly to Never Land

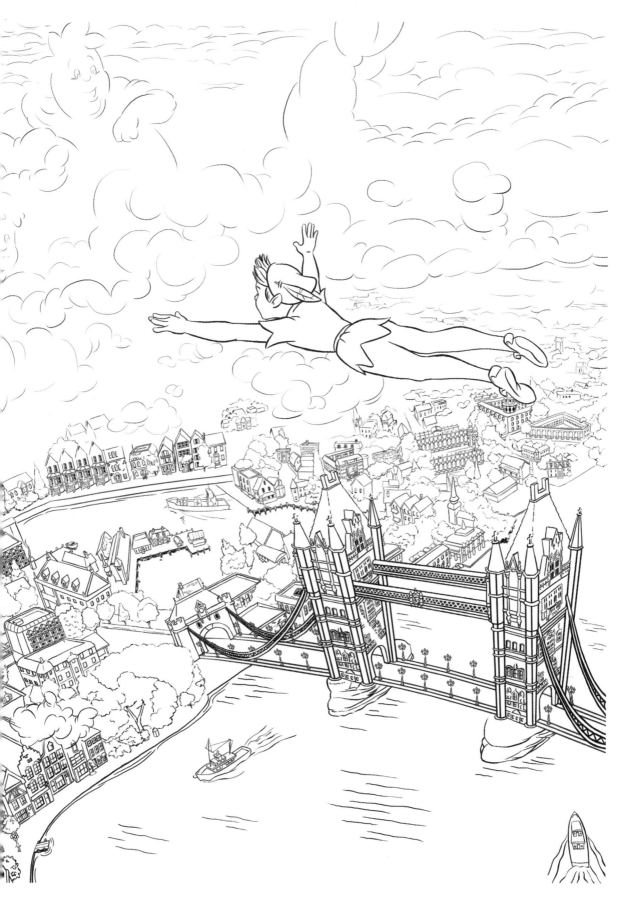

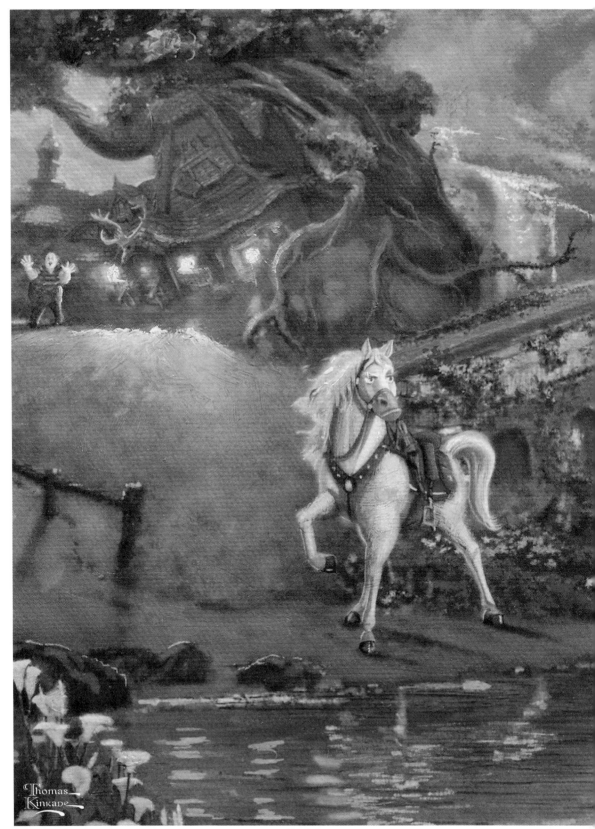

Tangled

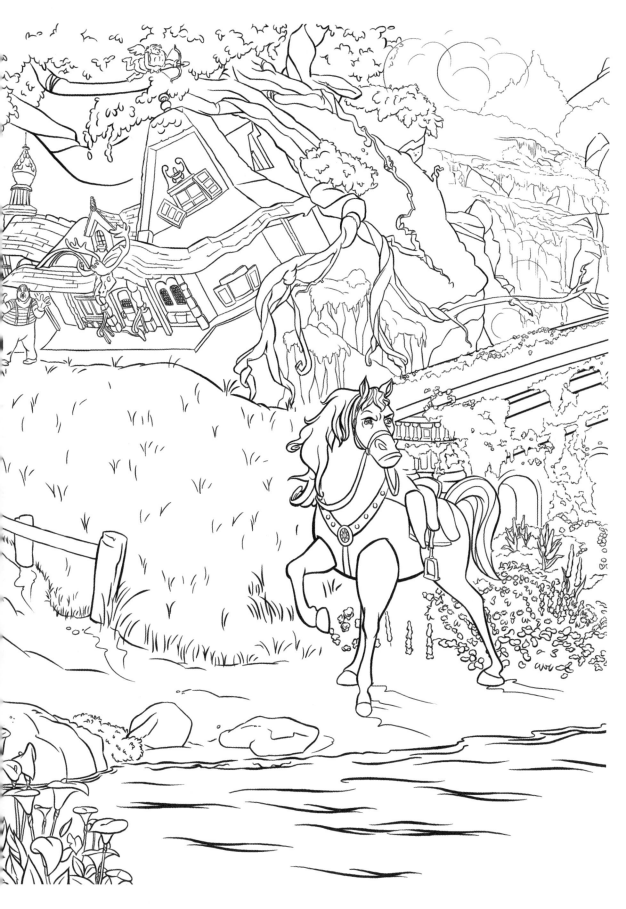

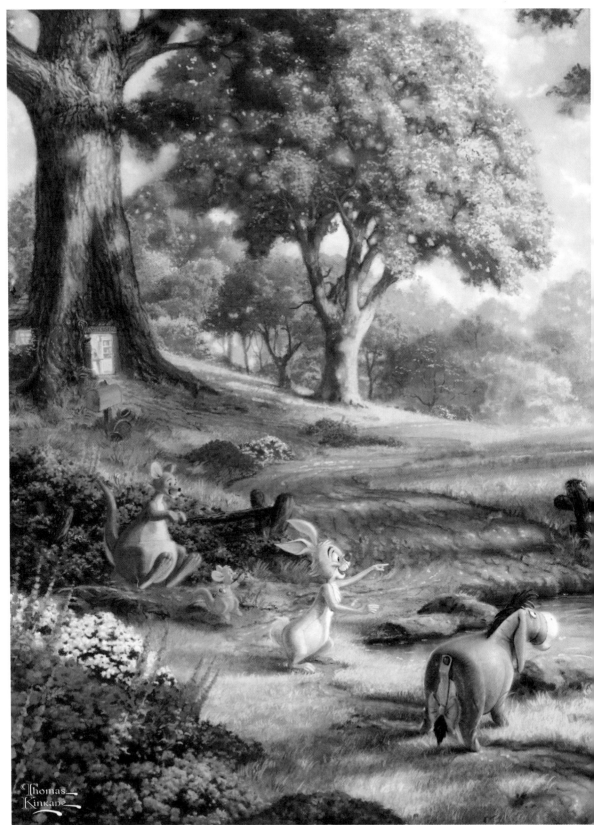

Winnie the Pooh I

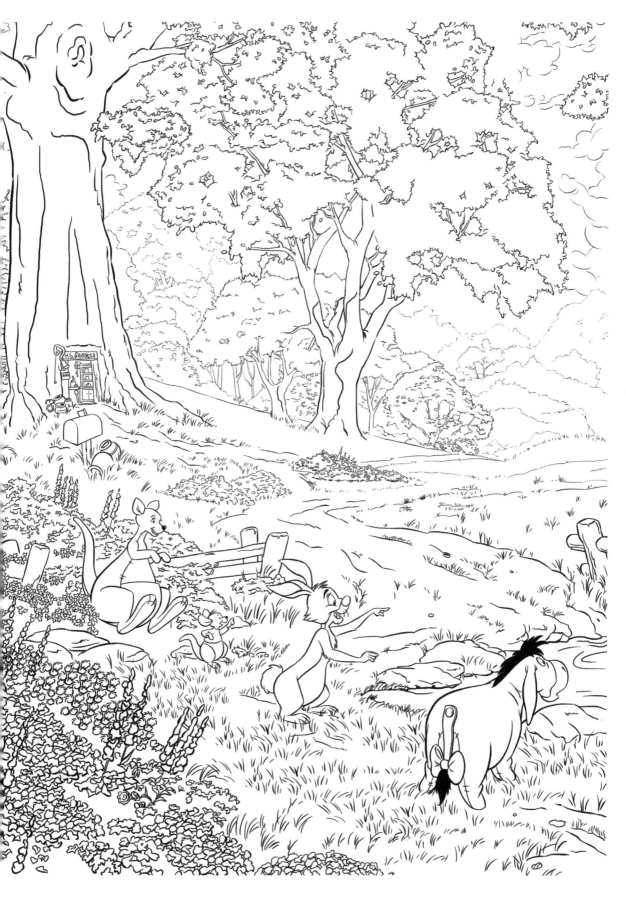

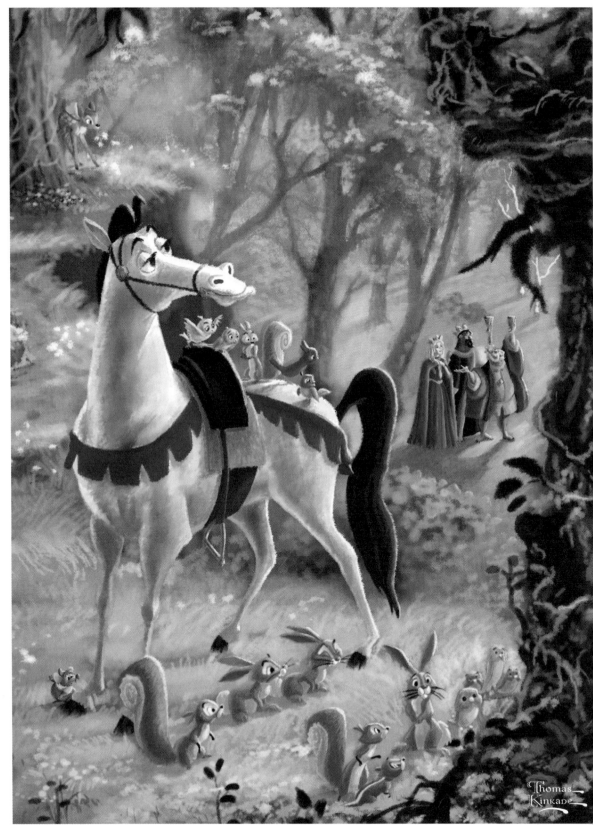

Sleeping Beauty

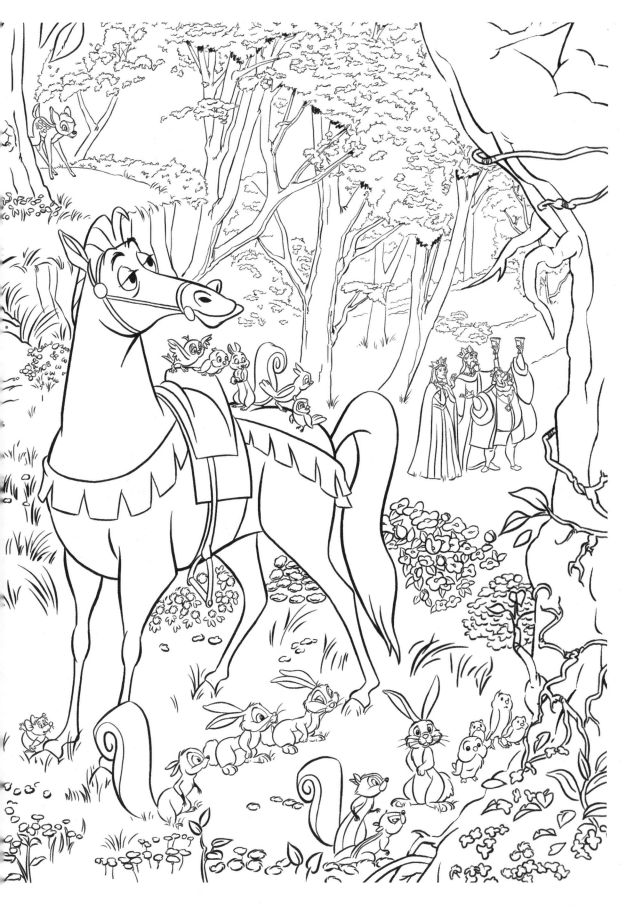

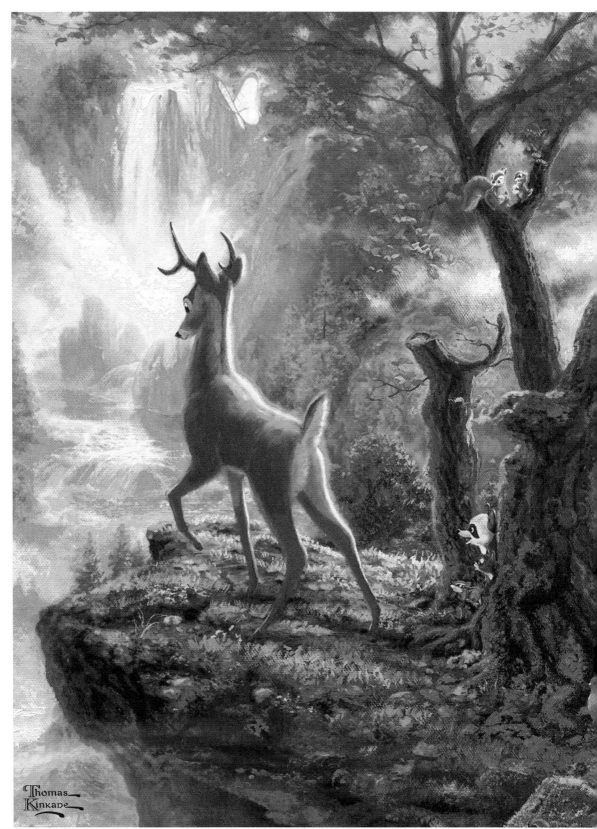

Bambi's First Year

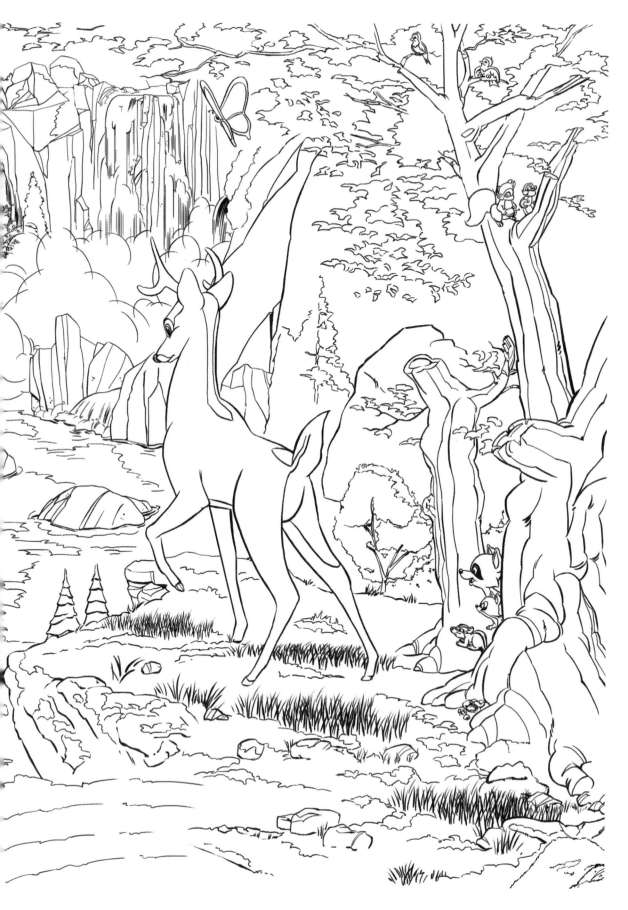

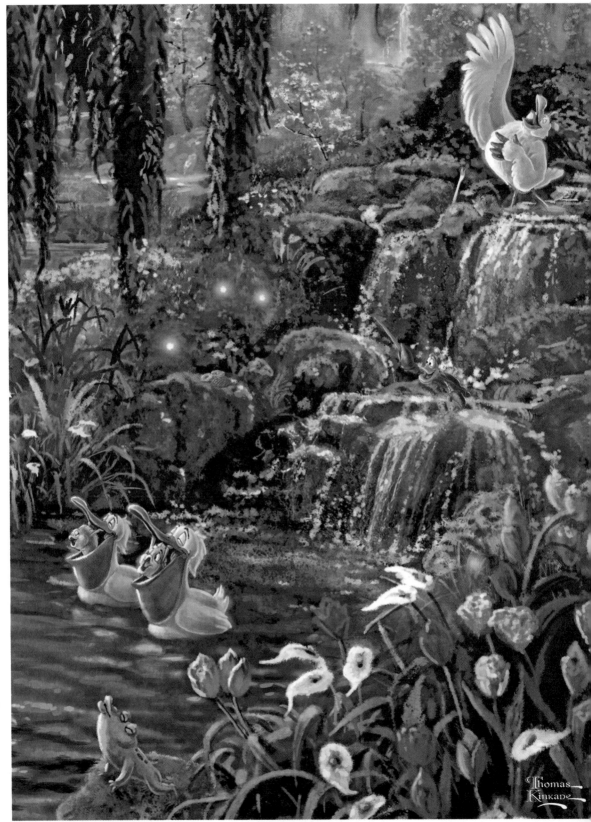

The Little Mermaid II